POSTER COLLECTION

JA! NEIN! YES! NO! SWISS POSTERS FOR DEMOCRACY

33

Herausgegeben von / Edited by Bettina Richter

Essay von / by Jakob Tanner

T0348995

MUSEUM FÜR GESTALTUNG ZÜRICH
PLAKATSAMMLUNG / POSTER COLLECTION

LARS MÜLLER PUBLISHERS

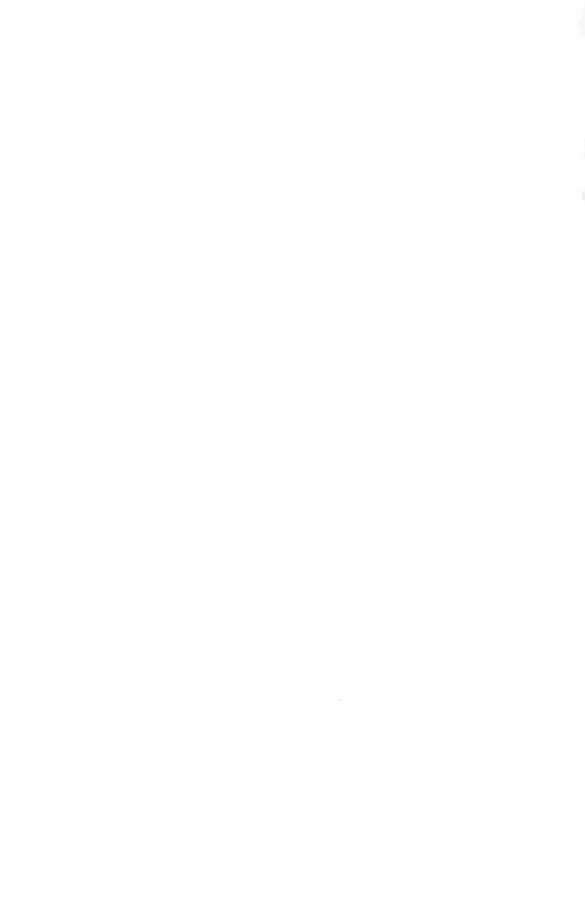

1 **Donald Brun**
Frauenstimmrecht Nein
1946

Seit Gründung des Bundesstaats 1848 ist die Schweizer Bevölkerung durch die Spielregeln der direkten Demokratie aktiv in politische Entscheidungsprozesse eingebunden. Immer wieder geht es dabei um Themen, die die Gemüter erhitzen und zu heftigen ideologischen Richtungskämpfen führen. Zeugnis dieser Auseinandersetzungen sind Abstimmungsplakate, die seit Beginn des 20. Jahrhunderts die Meinungsfindung beeinflussen. Klischeehafte Zuspitzungen, undifferenzierte Vereinfachungen, ein Repertoire drastischer Motive und verknappte Slogans entsprechen den Gesetzen des Mediums, das darauf ausgerichtet ist, die Massen manipulativ anzusprechen. Appelle an das «Wir-Gefühl» setzen in erster Linie auf Emotionalisierung, kaum auf rationale Aufklärung. Subtil verdichtete Botschaften oder eine grafisch innovative Sprache finden sich im Abstimmungsplakat kaum. Und dennoch haben sich viele Plakate ins kollektive Bildgedächtnis der Bevölkerung eingeschrieben und sind zu Ikonen schweizerischer Plakatkunst geworden.

In der ersten Hälfte des 20. Jahrhunderts dominiert eine lustvoll-polemische Gestaltung, die den politischen Kontrahenten nicht schont. Dessen Diffamierung steht im Vordergrund. Feindbilder, häufig auch in Form von Tiersymbolen, treten Heldenfiguren gegenüber. Der Rückgriff auf nationale Mythen und Heroen beschwört die Gemeinschaft und Einheit und dient der Sinn- und Identitätsstiftung. Spätestens seit den 1960er-Jahren werden diese permanent wiederholten Bilder und Narrative auch an den politischen Realitäten gemessen und damit einer kritischen Reflexion unterzogen. Dies gilt insbesondere für ihr Auftreten bei Themen wie der Neutralität, der direkten Demokratie oder der humanitären Tradition des Landes. Dennoch ist auffallend, dass nicht nur konservative, sondern auch progressive Strömungen und politische Kräfte in Abstimmungsplakaten gerne auf die helvetische Mythologie zurückgreifen und sie damit am Leben erhalten. Nach dem Zweiten Weltkrieg tritt im Zuge der allgemeinen Entideologisierung und durch neue Werbestrategien allmählich eine Beruhigung ein. Agenturen, die sich vor allem als Dienstleister verstehen, lösen Kunstschaffende und Autorendesignerinnen und -designer zunehmend ab, die sich mit den politischen Botschaften unmittelbarer identifiziert hatten. Neben vielen harmlosen, der Political Correctness verpflichteten Abstimmungsplakaten fallen im aktuellen Strassenbild jedoch auch Aushänge auf, die sich einer konsensorientierten Ästhetik verweigern und weiterhin politische Diskussionen auslösen.

Der vorliegende Band legt visuelle Argumentationsstrategien und bildrhetorische Ansätze offen, die die Schweizer Abstimmungsplakate von 1918 bis heute prägen. Gleichzeitig wird eine Plakatkategorie vorgestellt, die als Sonderform politischer Propaganda einzig in der Schweiz existiert. Als sensibler Gradmesser gesellschaftspolitischer Stimmungen und als wertvolle Zeitdokumente spiegeln Abstimmungsplakate sowohl schweizerische Mentalitätsgeschichte als auch globale Tendenzen wider.

Bettina Richter

PREFACE

Since the founding of Switzerland as a federal state in 1848, the Swiss people have actively been engaged in political decision-making processes through the principle of direct democracy. Again and again, this has involved issues that stir up emotions and lead to fierce ideological battles. These debates are documented by the campaign posters that have influenced public opinion since the early twentieth century. Clichéd exaggerations, undifferentiated simplifications, and a repertoire of drastic motifs and concise slogans reflect the nature of a medium designed to manipulatively target the masses. Appeals to a sense of belonging are based primarily on emotion and hardly on rational enlightenment. Subtly condensed messages or graphically innovative language are hardly ever found in campaign posters. Yet many posters have inscribed themselves into the collective visual memory and have become icons of Swiss poster art.

The first half of the twentieth century was dominated by passionately polemical design that did not go easy on the political adversary. The focus was on defaming the opponent. Bogeymen, often represented as animals, were juxtaposed with heroic figures. A recourse to national mythos and heroes evoked a sense of community and unity and served to establish meaning and identity. Since at least the 1960s, these endlessly repeating images and narratives have been measured against political realities and thus subjected to critical reflection. This applies particularly to their occurrence in relation to such issues as neutrality, direct democracy, and the country's humanitarian tradition. It is striking, however, that not only conservative but also progressive movements and political factions readily resort to Helvetic mythology in campaign posters, thus keeping it alive. After the Second World War, in the wake of a general de-ideologization and the introduction of new advertising strategies, things gradually calmed down. Agencies that primarily regarded themselves as service providers increasingly took the place of artists and designers who identified much more strongly with political messages. In addition to many harmless campaign posters committed to political correctness, however, posters that refuse to follow a consensus-oriented aesthetic and continue to trigger political discussions are currently also conspicuous on the streets.

This volume reveals the visual argumentation strategies and graphic approaches to political rhetoric that have characterized Swiss campaign posters from 1918 to the present. It also examines a category of posters that exist only in Switzerland as a distinct form of political propaganda. As a sensitive indicator of sociopolitical moods and as valuable historical documents, campaign posters reflect the history of Swiss mentality as well as global trends.

Bettina Richter

2 **Charles Affolter**
Semaine des 44 heures Oui
1958

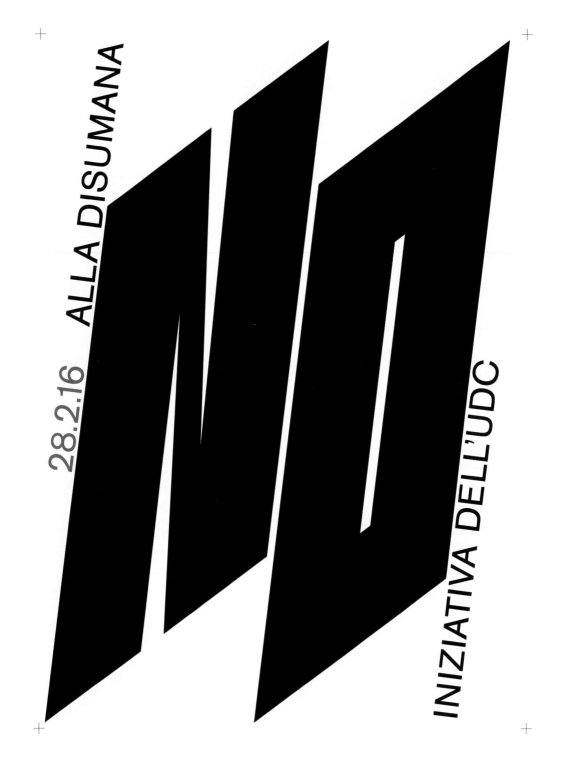

3 **Hubertus Design / Jonas Voegeli**
No alla disumana iniziativa dell'UDC
2016

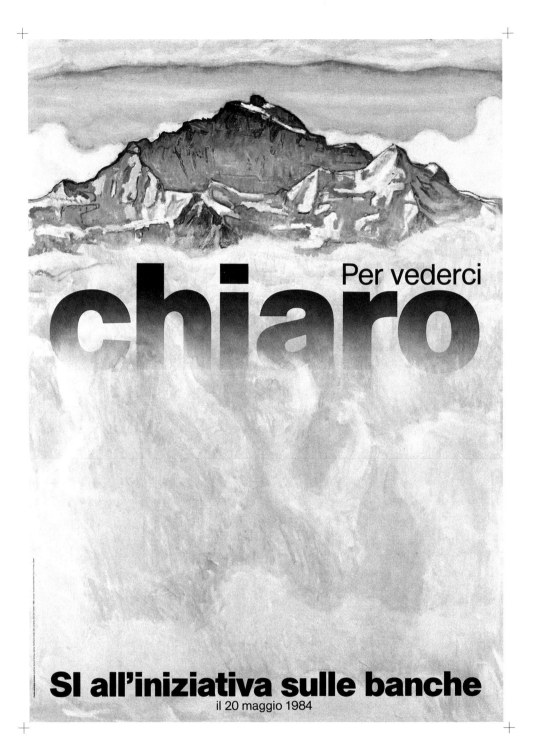

4 **Bernard Schlup**
Per vederci chiaro / Sì all'iniziativa sulle banche
1984

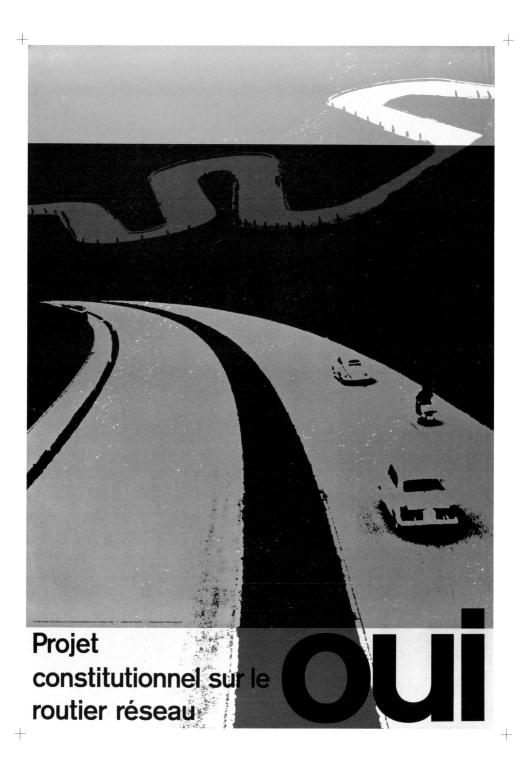

5 **Josef Müller-Brockmann**
Projet constitutionnel sur le routier réseau Oui
1958

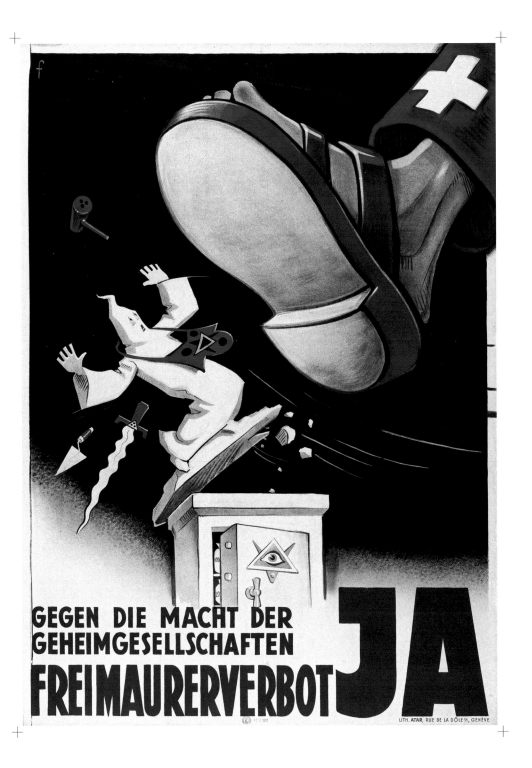

6 **Noël Fontanet**
Freimaurerverbot Ja
1937

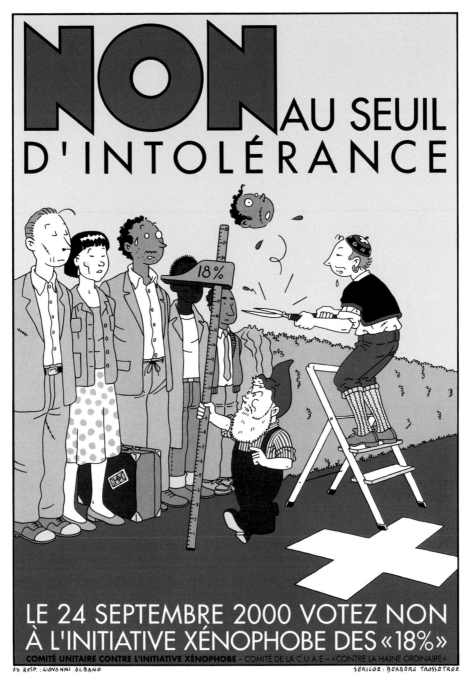

7 **Exem**
Non au seuil d'intolérance
2000

DIE VOLKSABSTIMMUNG ALS INSTRUMENT DER DIREKTEN DEMOKRATIE IN DER SCHWEIZ

Die sowohl auf kommunaler als auch kantonaler oder eidgenössischer Ebene regelmässig durchgeführten Volksabstimmungen sind ein wichtiges Element des auf Konkordanz ausgelegten politischen Systems der Schweiz. Rund die Hälfte aller weltweiten Volksabstimmungen findet in der Schweiz statt. Seit der Gründung des Bundesstaates 1848 waren es mehr als 635.

Politische Anliegen, die vorab durch eine Volksinitiative eingebracht wurden, sowie obligatorische oder fakultative Referenden bilden die Vorlagen für Abstimmungen. Damit eine Volksinitiative zustande kommt, müssen 100 000 Stimmberechtigte innerhalb von 18 Monaten mit ihrer Unterschrift eine Verfassungsänderung verlangen. Volksinitiativen gehen von Bürgerinnen und Bürgern, Interessenverbänden und Parteien aus, nicht von der Regierung oder vom Parlament; das Parlament kann einen Gegenentwurf erarbeiten. Die Anzahl der Volksinitiativen nimmt seit den 1980er-Jahren kontinuierlich zu, was belegt, dass die Volksinitiative in der direkten Demokratie der Schweiz ein wichtiger Anstoss für Veränderungen ist – oft genügt bereits ihre Androhung, damit der Gesetzgeber aktiv wird.

Beim obligatorischen Referendum entscheidet das Stimmvolk über eine vom Parlament beschlossene Verfassungsänderung, über einen Beitritt zu Organisationen für kollektive Sicherheit oder zu supranationalen Gemeinschaften sowie über dringlich erklärte Bundesgesetze, die keine Verfassungsgrundlage haben und deren Geltungsdauer ein Jahr übersteigt.

Beim fakultativen Referendum entscheidet das Stimmvolk über einen vom Parlament verabschiedeten referendumsfähigen Erlass, beispielsweise über Bundesgesetze oder wichtige völkerrechtliche Verträge. Wenn mindestens 50 000 Stimmberechtigte oder acht Kantone innerhalb von 100 Tagen nach der amtlichen Veröffentlichung dies verlangen, wird die bereits verabschiedete Vorlage in einer Volksabstimmung überprüft.

Bei eidgenössischen Abstimmungen sind alle Schweizer Staatsangehörigen ab 18 Jahren stimmberechtigt, auch wenn sie im Ausland wohnhaft sind. In manchen Kantonen dürfen auf kommunaler Ebene und unter bestimmten Bedingungen auch niedergelassene ausländische Bürgerinnen und Bürger abstimmen. Die Stimmbeteiligung hängt entscheidend vom Inhalt einer Vorlage ab und beträgt auf Bundesebene durchschnittlich rund 45 Prozent.

Über die Annahme oder Ablehnung einer Vorlage entscheidet die einfache Mehrheit der abgegebenen Stimmen. Auf Bundesebene werden bei Abstimmungen über Volksinitiativen oder bei obligatorischen Referenden zudem die Resultate in den Kantonen berücksichtigt. Dies bedeutet konkret, dass eine Vorlage nur dann angenommen wird, wenn sie sowohl das Volksmehr erreicht, also eine Mehrheit aller Stimmen, als auch das sogenannte Ständemehr, die Mehrheit aller Kantone.

DIRECT POPULAR VOTES AS AN INSTRUMENT OF DIRECT DEMOCRACY IN SWITZERLAND

Direct votes by the people on particular policy issues are held at all political levels in Switzerland (municipal, cantonal, federal). They are a central instrument of direct democracy and thus an important element of Switzerland's consociational political system. Around half of all direct popular votes in the world are held in Switzerland. Since the founding of Switzerland as a federal state in 1848, there have been a total of 635.

Direct votes are triggered by mandatory referenda, optional referenda, and popular initiatives on a particular political issue. For a popular initiative to be successful, 100,000 signatures must be collected from eligible voters within eighteen months. By signing such a list, voters show they are in favor of the proposed constitutional amendment. Popular initiatives are launched by citizens, interest groups, and political parties, but not by the federal government or parliament. However, parliament may draw up a counter-proposal. Since the 1980s, the number of popular initiatives has increased steadily, showing that in Switzerland's direct democracy, they provide an important impetus for political change. Sometimes even the threat of such initiatives suffices to prod legislators into action.

In mandatory referenda, the electorate votes on constitutional amendments adopted by parliament, membership in collective security organizations or supranational communities, or urgently declared federal laws that have no constitutional basis and will be in effect for more than one year.

In optional referenda, the electorate votes on laws enacted by parliament that are subject to a referendum, such as federal legislation and important international treaties. If at least 50,000 eligible voters or eight cantons request a referendum within 100 days after publication of the adopted legislation, it will be put to a popular vote.

All Swiss nationals aged eighteen and over are entitled to vote at the federal level, regardless of whether they live in Switzerland or abroad. In certain cantons, foreign nationals may vote at the municipal level subject to certain conditions. Voter participation depends mainly on the content of a proposal and averages around 45 percent at the federal level.

The acceptance or rejection of a bill is decided by a simple majority of the votes cast. If popular initiatives or mandatory referenda are voted on at the federal level, cantonal results are also taken into account. A proposal is only adopted if it is supported by a majority of all voters (popular majority) and a majority of cantons.

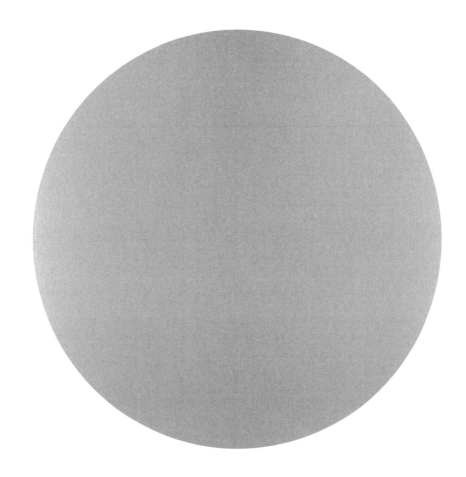

8 **Automatico / Demian Conrad**
Sì
2016

9 **Melchior Annen**
Gerechtigkeit erhöht ein Volk!
1918

«BILDGALERIE DER STRASSE»:
ABSTIMMUNGSPLAKATE IN DER SCHWEIZ DES 20. JAHRHUNDERTS

Jakob Tanner

«Auf den grossen eidgenössischen Hosenlupf im Herbst 1919, wo der Nationalrat zum ersten Mal nach dem System der Verhältniswahl bestellt wurde und wo eine jede politische Gruppe für die eigene Geltung und zur Erringung oder Bewahrung der künftigen Meisterschaft im Schweizerhause ihr Bestes und Äusserstes an Propaganda leisten musste, bedienten sich alle ausschlaggebenden Parteien des neuen wirksamsten Mittels der künstlerischen Plakate und Flugblätter» – so äusserte sich 1920 Edwin Lüthy, Direktor der Allgemeinen Plakatgesellschaft Basel.[1] Dass die Umstellung von der Majorz- auf die Proporzwahl im Oktober 1918 angenommen worden war, lässt sich auch auf das Framing eines Abstimmungsplakats zurückführen, das die demokratische Parole «Gerechtigkeit erhöht ein Volk!» mit der Kontrastierung von Volksherrschaft und Kapitalmacht illustriert hatte 9.

DER ERSTE WELTKRIEG ALS KATALYSATOR DER POLITISCHEN PROPAGANDA

Das politische Plakat kam am Ende des Ersten Weltkrieges nicht aus heiterem Himmel. Die Inkubationsphase der kommerziellen Plakatwerbung war das Fin de Siècle, auch Belle Époque genannt. Ausgehend von Frankreich setzte sich ein radikal neuer Plakatstil durch. In der Schweiz etablierte sich das Plakat um die Jahrhundertwende in der Tourismusförderung, Unterhaltungskultur sowie Warenwerbung. Künstlerinnen und Künstler inszenierten Landschaften, insbesondere Seen und Berge, als Sehnsuchtsorte. Gleichzeitig versuchten sich rechtlich geschützte Markenartikel von der Tendenz der Uniformierung in der industriellen Massenproduktion abzuheben. Neben den schon älteren Importetiketten und Brands wurden neue Labels und Logos populär. Sie versprachen der Kundschaft Orientierung in einem unübersichtlichen Warenangebot.[2]

In dieser Zeit kam auch der Begriff «Reklame» auf. Künstlerinnen und Künstler optimierten die optische Durchschlagskraft ihrer Plakate durch Vereinfachung, Verdichtung und Verknappung bekannter, jedoch suggestiv arrangierter Bildelemente. Ab 1900 griffen sie auch neue Erkenntnisse aus der Werbepsychologie auf. In der politischen Arena hingegen schlug sich dieser Bilderboom vorerst kaum nieder. Der Kulturkampf und der sich verschärfende Klassenkampf wurden vor 1914 über das Leitmedium der Parteizeitungen ausgetragen; dazu kamen Reden, Zeitschriften, Broschüren sowie Flugblätter.

Der Erste Weltkrieg sollte dies ändern, er wuchs sich rasch zum globalen Medienereignis aus und wurde als «Kampf um Begriffe und Bilder, um Sympathie und Anerkennung» geführt. In den Krieg führenden Staaten entstanden professionelle «Sinn-Industrien», die den Toten- und Opferkult fürs Vaterland stärkten. So wurde die Propaganda «zum Schwungrad eines Krieges, der nach und nach die ganze Gesellschaft in seinen Dienst stellte».[3] Plakate, die für Soldaten, Waffen und Wehranleihen warben, bekräftigten die

1 Edwin Lüthy, *Das künstlerische politische Plakat in der Schweiz,* Basel 1920, S. 6/7.

2 Claudia Steinfels, *Herbert Leupin 1916–1999, Werbegrafiker. Sein Leben, sein Werk, seine Bedeutung,* Diss. Universität Zürich, Zürich 2003; Daniela Flury-Schütz, *Der Blick auf die Landschaft: Landschaftsbilder auf den Tourismusplakaten Luzerns und der Region Vierwaldstättersee 1880–1960,* Lizentiatsarbeit Universität Zürich, Zürich 2007.

3 Michael Jeismann, «Propaganda», in: Gerhard Hirschfeld, Gerd Krumeich, Irina Renz (Hg.), *Enzyklopädie Erster Weltkrieg,* Paderborn 2009, S. 198–209, S. 202.

nationale Einheit. Sie dienten der Stilllegung der Politik nach innen zwecks Kraftsteigerung nach aussen. Als der Krieg nach mehr als vier Jahren mit der wirtschaftlichen Erschöpfung und dem moralisch-institutionellen Bankrott von Staaten und Imperien zu Ende ging, standen die Zeichen auf Veränderung. Mit Hungerrevolten, Sozialprotesten, Reformbegehren und revolutionären Aspirationen kehrte der innenpolitische Kampf in allen Ländern mit äusserster Schärfe zurück.

KOMMERZIELLE REKLAME UND POLITISCHES PLAKAT

Dies gab dem politischen Plakat europaweit einen enormen Auftrieb. In seiner formalen Gestaltung zeigten sich in den Nachkriegsjahren Einflüsse von Futurismus, Expressionismus, De Stijl, Bauhaus und Agitprop. In Deutschland erkannte die sozialdemokratische Regierung im neuen Bildmedium ein Vehikel des gesellschaftlichen Fortschritts. Eine 1919 «in amtlichem Auftrag» herausgegebene Schrift über «das politische Plakat» betonte den Unterschied zwischen dem alten kapitalistischen und dem aufkommenden sozialistischen Stil. Das ausgebrannte, kommerziell aggressive, «moderne Plakat (…) schreit uns ein Wort zu und presst uns gleichzeitig einen Gegenstand in die Netzhaut» und ist in dieser «letzten allerlogischsten Form (…) einseitig, laut und schroff.» Ganz anders das an Resonanz gewinnende «sozialistische Werbeplakat», das «ein neues Kapitel» politischer Propaganda eröffne, weil es «nicht für eine Firma, sondern für eine Idee» werbe und in der Kunst «eine Mitteilung von Mensch zu Mensch!» sehe.[4]

Auch die neutrale Schweiz war wirtschaftlich, sozial, kulturell, diplomatisch und ideell in den zunehmend totalen und globalen Krieg involviert. Doch während sich in Deutschland im November 1918 ein tiefgreifender Umbruch ereignete, stand das eidgenössische Staatswesen im Zeichen der Kontinuität. Die hochfliegenden Reformhoffnungen der Arbeiter- und Frauenbewegung wurden durch den bedingungslosen Abbruch des Landesstreiks gedämpft. Inspiriert durch US-amerikanische Werbestrategien suchten Künstlerinnen und Künstler, Grafikerinnen und Grafiker weniger nach einer grundsätzlichen Alternative zum Geschäftsplakat, sondern transponierten dessen Prinzipien auf die kompetitiv organisierte Parteien- und Verbandsdemokratie. So kreierten sie eine populäre «Bildgalerie der Strasse» für die «breitesten Massen»: «Das künstlerische Plakat soll und kann aber jeden auf der Strasse gedankenlos Vorüberbummelnden oder gedankenschwer Vorüberhastenden mit telepathischem Griffe fesseln, sein Gehirn durch ein kurz orientierendes Schlagwort in die gewollte politische Richtung drängen.»[5]

Die «Allgewalt und Unentrinnbarkeit» des «guten politischen Künstlerplakats» wirkte allerdings nicht absolut. Die emotionale Breitenwirkung wurde beschränkt durch «die Konkurrenz der (…) Parteien». In dieser Ökonomie der Aufmerksamkeit sah Edwin Lüthy genau jene «Moral der Reklame» am Werk, welche die kommerzielle Sphäre dominierte: «Für schlechte, unzeitgemässe, bei einem politisch reifen Volke demagogische Parteiziele wird auch die beste künstlerische Propaganda auf die Dauer nichts

4 *Das politische Plakat,* hg. in amtlichem Auftrag, Charlottenburg 1919, S. 14.
5 Lüthy 1920, S. 3–4. Einen Überblick für die Schweiz geben: Bruno Margadant, *«Für das Volk – Gegen das Kapital».*
Plakate der schweizerischen Arbeiterbewegung von 1919 bis 1973, Zürich 1973; Willy Rotzler, Karl Wobmann, *Politische*
und soziale Plakate der Schweiz. Ein historischer Querschnitt, Zürich 1985; vgl. auch Kai Artinger, «Das politische
Plakat – Einige Bemerkungen zur Funktion und Geschichte», in: ders. (Hg.), *Die Grundrechte im Spiegel des Plakats*
von 1919 bis 1999, Berlin 2000, S. 15–22.

nützen. Ja, eine zu laute Reklame für eine ‹faule Sache›, das wissen wir alle, lässt – ist bloss der erste täuschende Bluff vorbei – bei einem geistig gesunden Publikum nur wachsendes Misstrauen entstehen, das den beabsichtigten Propagandazweck ins Negative verkehrt.» Da alle Parteien an ihre gute Sache glaubten, war der Proliferation des Plakats keine Grenze gesetzt. Auch hier nahm die «sozialistische Partei (…) als Oppositions- und als ungestüm mit dem Zeitgeist paktierende Umsturzpartei» das politische Plakat pionierhaft in Gebrauch 13, 18. Doch der Bürger-Bauern-Block zog rasch nach und nutzte dieses «zeitgemässeste und wirksamste Propagandamittel»[6] 31, 32, 119.

Für diesen flächendeckenden Einsatz stand wie kein anderer der Plakatmacher Otto Baumberger (1889–1961), der für Wirtschaft und Politik gleichermassen arbeitete und dem die Schweiz ziemlich abnutzungsresistente Sujets verdankt.[7] 1920 erklärte Baumberger, dass das politische Plakat eine zündende Idee vermitteln muss: «Es muss (…) ein ‹Schlager› sein, einfach lapidar, auf das Verständnis auch der breitesten Massen zugeschnitten, satirisch, bösartig oder sentimental, aber immer muss eine einfache, jedem fassliche klare Idee absolut zwingend an die Köpfe geworfen werden.»[8] So sehr sich Baumberger persönlich mit seinen Plakatmotiven identifizierte, so flexibel erwies er sich politisch, indem er unter anderem Aufträge für die Sozialdemokratie und den Freisinn ausführte.

FRAUENSTIMMRECHT, VÖLKERBUND UND VERMÖGENSABGABE IM BILD

In den 1920er-Jahren herrschte in der Schweiz trotz Kompromissen und Reformen eine schrille Klassenkampfrhetorik vor. Bürgerlichen Angstmacher-Plakaten, die Sozialismus mit Chaos und Zerstörung identifizierten, stand eine linke Kraftmeier-Mentalität gegenüber, welche die körperliche und geistige Stärke arbeitender Menschen inszenierte. Bereits im Juni 1918 lehnten die Stimmbürger eine direkte Bundessteuer ab: Der Prolet mit den roten Hosen wirkte in der Romandie und bei den Katholisch-Konservativen nicht als Sympathieträger 103. Der Plakatschöpfer Hugo Laubi bemerkte selbstkritisch: «Der Sozi, der hier hauptsächlich nur erpressen will, hat somit Leute anderer Parteien eher vor den Kopf gestossen.»[9] Im Oktober 1920 wirkte das Bild eines faulen Schulden-Schmarotzers ebenso kontraproduktiv 101. Der Versuch, mit dieser Negativfigur die Einführung der 48-Stunden-Woche in den Eidgenössischen Verkehrsbetrieben zu Fall zu bringen, scheiterte.

Besonders einprägsame Bilder entstanden rund um die sechs kantonalen Volksabstimmungen zur Einführung des Frauenstimmrechts, die zwischen 1919 und 1921 stattfanden. Grafikerinnen wie Margrit Gams und Dora Hauth-Trachsler visualisierten auf unterschiedliche Weise die geforderte Geschlechtergleichberechtigung 75, 76. Letztere schrieb dazu, «erst in vollkommener Klarheit mit seiner Überzeugung» werde es möglich, «Farben, Linienführung, Flächen etc. in erwogenen Einklang zu bringen mit der ihnen zu Grunde liegenden Idee».[10] Die herausragenden Patriarchen

6 Alle Zitate aus: Lüthy 1920, S. 5/6.
7 Zum «Machen» von Plakaten schrieb Baumberger Ende der 1930er-Jahre in sein Tagebuch: «Ein Kunstwerk entsteht. Ein Werk der sogenannten ‹angewandten Kunst› wird GEMACHT.» Zit. in: Steinfels 2003, S. 46.
8 Baumberger, zit. in: Lüthy 1920, S. 8.
9 Laubi, zit. in: Lüthy 1920, S. 11.
10 Hauth-Trachsler, zit. in: Lüthy 1920, S. 9.

der Plakatkunst konterkarierten diesen Emanzipationsanspruch mit Schreckbildern von Frauen, die ihre Weiblichkeit dem politischen Engagement opfern [65], oder mit mütterlichen Schutzmotiven, die als Antithese zum exponierten männlichen Politikbetrieb ins Bild gesetzt wurden [67].

Höhepunkte der politischen Plakatwerbung waren die beiden Plebiszite zum Beitritt der Schweiz zum Völkerbund vom Mai 1920 (mit 56 Prozent Ja-Stimmen und knappem Ständemehr angenommen) und zur sozialdemokratischen Volksinitiative für eine «Einmalige Vermögensabgabe» vom Dezember 1922 (mit 87 Prozent Nein-Stimmen haushoch abgeschmettert). In beiden Abstimmungskämpfen erreichte der finanzielle Einsatz Spitzenwerte, und politische Plakate wurden in Rekordauflagen ausgehängt, was in einer vergleichsweise hohen Stimmbeteiligung resultierte. Beide Seiten schöpften aus dem Bildervorrat der nationalen Gebrauchsgeschichte: Schweizer Berge, Wilhelm Tell, Rütlischwur, Älpler, Helvetia [35, 116]. Gegen die Vermögensabgabe wurde zudem eine veritable Angstkampagne mit Ratten, Krallenhänden, roten Volksverführern, Totengräbern, Absturz- und Untergangsszenarien lanciert [14, 100, 104].

In der Zwischenkriegszeit vermittelten die kommerzielle und die politische Werbung frappant gegenläufige Botschaften. Während Erstere mit der «Schweizerwoche» und der Armbrust als Qualitätszeichen einem wirtschaftlichen Nationalpatriotismus verpflichtet war und in der Aussenwahrnehmung die herausragenden Alleinstellungsmerkmale der Schweiz zu profilieren versuchte, drückten sich in der politischen Propaganda der demokratische Pluralismus und die trotz aufkommender Konkordanzdemokratie anhaltende innere Spaltung des Landes aus [6, 12, 36, 40, 41].

HELVETOZENTRISCHE IKONOGRAFIEN
In der Zeit nach dem Zweiten Weltkrieg hatte das politische Plakat nochmals eine durch stilistische Innovationen stimulierte Blütezeit. Das Mythen-Arsenal der Nationalgeschichte erwies sich indessen als Dauerbrenner. Eine Ikonografie der internationalen Abhängigkeit, der globalen Vernetztheit und der erdumspannenden Solidarität konnte sich unter dem imaginären Schutzschild der Nation kaum entwickeln. Ein vom Künstler Hans Erni gestaltetes Plakat der Gesellschaft Schweiz-Sowjetunion wurde Anfang 1945 verboten [51]. Das 1946 im Kanton Zürich für den Ausbau des Flughafens Kloten werbende Plakat wiederum versteckte die wegen ihrer wirtschaftlichen Kollaboration mit dem NS-Regime zur Rechenschaft gezogene Schweiz hinter einem überdimensionierten Wegweiser [47]. Auch die visuelle Revolte der 68er-Bewegung änderte wenig an dieser nationalen Selbstbezogenheit.

In den ausgehenden 1960er-Jahren diagnostizierte der Politologe Erich Gruner eine Krise der Parteien. Er kritisierte sowohl die demokratiefeindliche Rede vom «Meinungsterror der Parteien» als auch den technokratischen Glauben daran, die Politik durch Experten und computergestützte «Versachlichung» ersetzen zu können. Gruner

konstatierte einen tiefgreifenden Medienwandel, verbunden mit der wachsenden Attraktivität populärkultureller «Helden» aus Sport, Film und Beatmusik. Den «Ruf nach Opposition» führte er darauf zurück, dass Abstimmungs- und Wahlkämpfe zum Scheinwettbewerb und zur medialen Farce verkommen seien: «Die Parteien treten zwar immer noch im Kostüm ihrer historischen Ideologien auf, aber diese Maskerade raubt ihnen jede Glaubwürdigkeit.»[11] Unter diesen Bedingungen weisen Sales Promotion und politische Mobilisierung eine analoge Funktionalität auf: Die Vermittlung alternativer Gesellschaftsentwürfe weicht dem Abtasten der Wählermeinung, die anschliessend parteispezifisch gefiltert per Plakat in den öffentlichen Raum zurückprojiziert wird.

Im Schweizer Plakat lässt sich über den Kalten Krieg hinaus ein Stagnieren im schweizerischen Sonderfall konstatieren. Es gab zwar immer wieder Ausbruchsversuche aus dem ikonografischen Nationalcontainer 8, 42, 66, nachhaltig wirkten diese jedoch nicht. Mit dem in den 1990er-Jahren einsetzenden Aufstieg der Schweizerischen Volkspartei (SVP) erhielt die (bereits 1919 beschworene) «ungeheure Macht des bildlichen Plakates auf die Massen» eine neue Virulenz. Die schiere Menge rechtsnationaler Plakatanschläge wurde zum Politikum und bekräftigte die Forderung nach finanzieller Transparenz. Zudem reizte die SVP die Grenzen des Zeigbaren immer weiter aus und provozierte mit rassistischen Darstellungen mediale Skandale 55, 93, 94.

Gegenstrategien versuchten sich in «unfreundlichen Übernahmen», indem etwa die bedrohlichen Silhouetten von Minaretten in einen helvetischen Raketenexport umgedeutet wurden 60, 61. Auf demagogische Motive, die an nationalen Egoismus und Fremdenfeindlichkeit appellieren, wird vermehrt mit einfachen Parolen- und Schriftplakaten reagiert, die nicht visuelle Sujets, sondern starke Worte ins Zentrum der Massenkommunikation rücken 3, 57, 130–134. Die Emergenz und die widersprüchlichen Effekte von Social Media verstärken dabei ältere Trends und schaffen gleichzeitig neue Verhältnisse. In der volatilen Bilderwelt des 21. Jahrhunderts oszilliert die politische Propaganda zwischen demokratischem Crowdfunding und kapitalistischen Grossspenden und generiert damit Einnahmen, welche den Plakatauftritt und den Bilderreigen der Politik in Gang halten.

11 Erich Gruner, *Die Parteien in der Schweiz,* Bern 1969, S. 247 u. 256. Vgl. auch Zoé Kergomard, *Wahlen ohne Kampf? Schweizer Parteien auf Stimmenfang, 1947–1983,* Basel 2020.

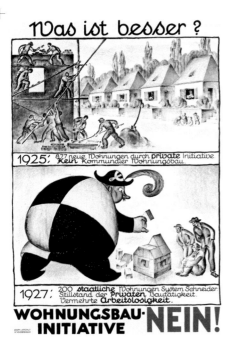

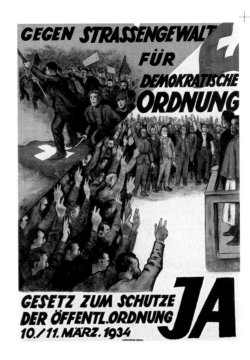

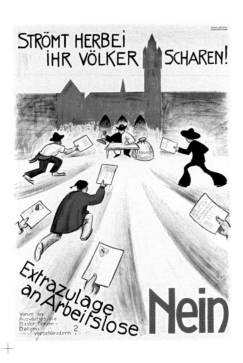

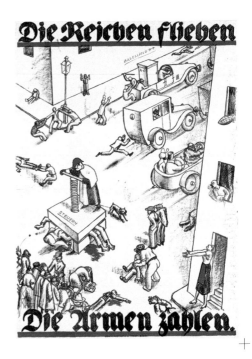

10 **Otto Jakob Plattner**
Wohnungsbau-Initiative Nein!
1926

11 **Ferdinand Schott**
Extrazulage an Arbeitslose Nein
1926

12 **Emil Cardinaux**
Gesetz zum Schutze der öffentl. Ordnung Ja
1934

13 **Niklaus Stoecklin**
Die Reichen fliehen / Die Armen zahlen.
1921

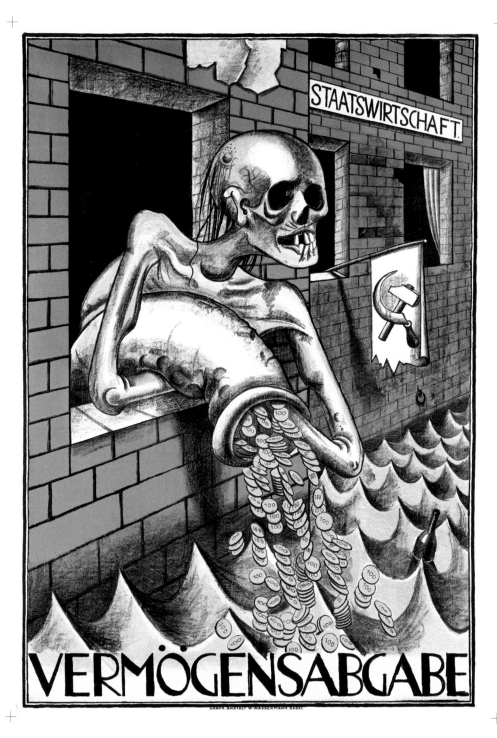

STAATSWIRTSCHAFT.

VERMÖGENSABGABE

GRAPH. ANSTALT W. WASSERMANN, BASEL

14 **Niklaus Stoecklin**
Vermögensabgabe
1922

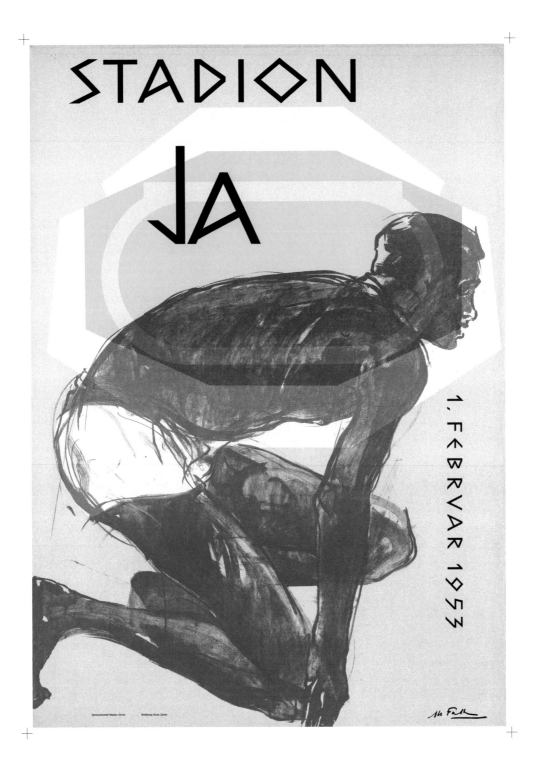

15 **Hans Falk**
Stadion Ja
1953

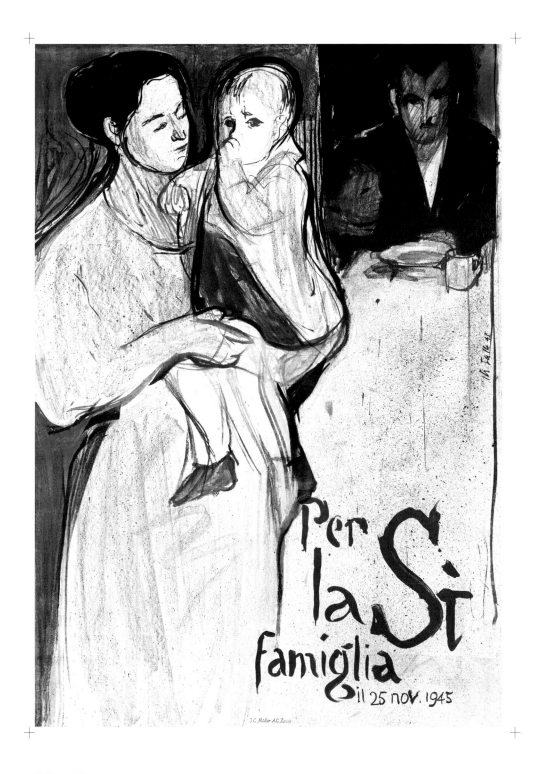

16 **Hans Falk**
Per la famiglia Sì il 25 nov. 1945
1945

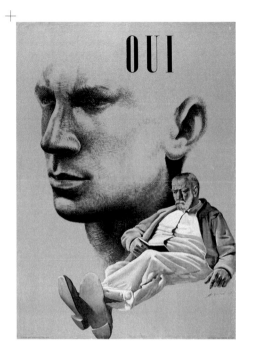

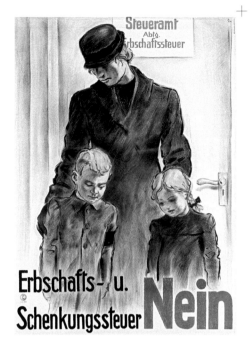

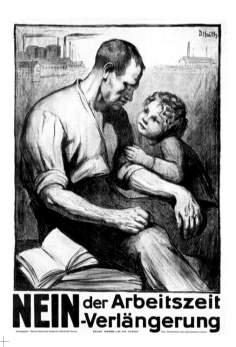

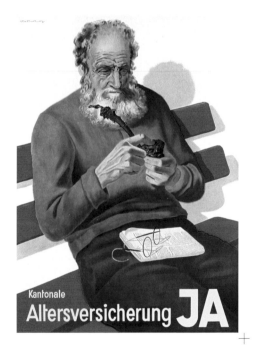

17 **Hans Erni**
Oui
1947

18 **Dora Hauth-Trachsler**
Nein der Arbeitszeit-Verlängerung
1924

19 **Hugo Laubi**
Erbschafts- u. Schenkungssteuer Nein
1936

20 **Viktor Rutz**
Kantonale Altersversicherung Ja
1941

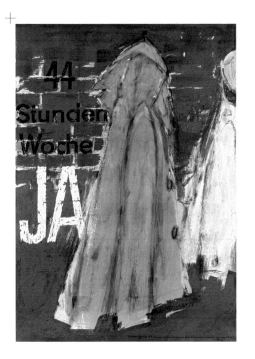

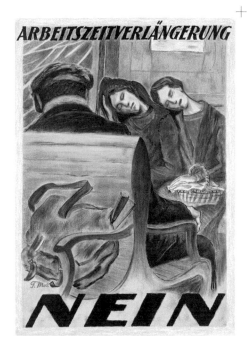

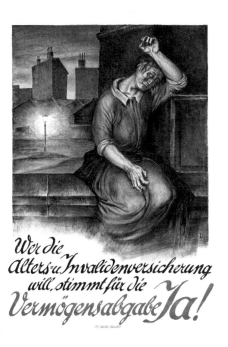

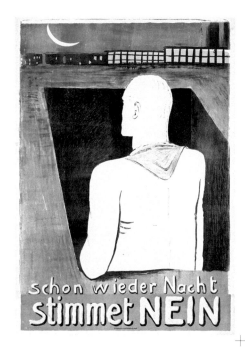

21 **Heiner Bauer**
44 Stunden Woche Ja
1958

22 **József Divéky**
Vermögensabgabe Ja!
1922

23 **Florentin Moll**
Arbeitszeitverlängerung Nein
1924

24 **Alfred Heinrich Pellegrini**
Schon wieder Nacht / Stimmet Nein
1924

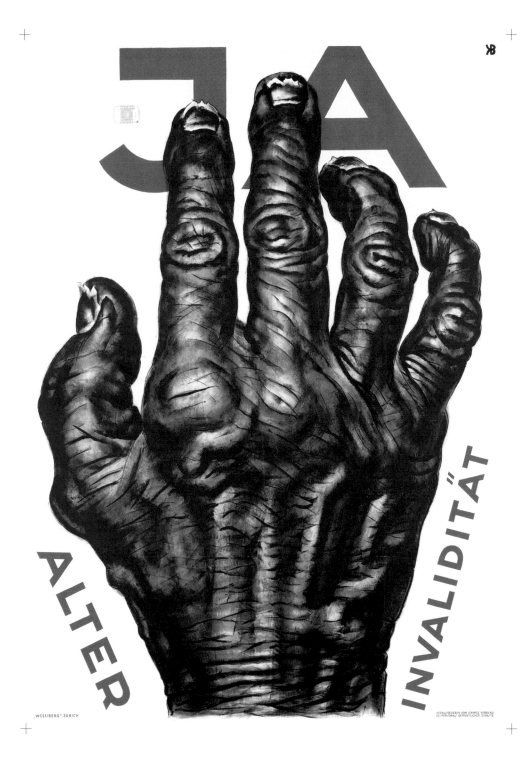

25 **Karl Bickel**
Ja / Alter / Invalidität
1925

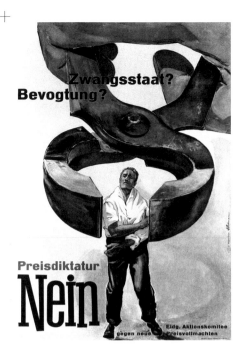

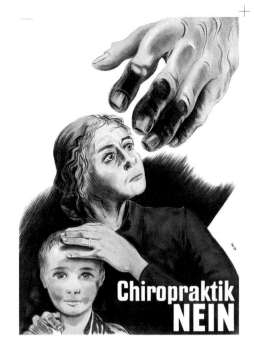

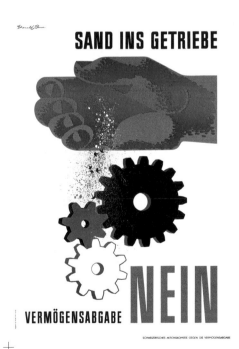

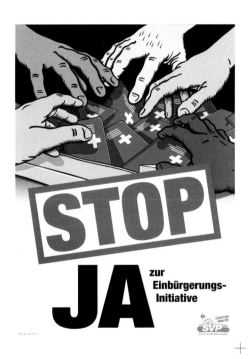

26 Kaspar Gisler Reklameberatung / Hannes Portmann
Preisdiktatur Nein
1952

27 Donald Brun
Vermögensabgabe Nein
1952

28 Otto Baumberger
Chiropraktik Nein
1939

29 Goal AG für Werbung und Public Relations
Stop / Ja zur Einbürgerungsinitiative
2008

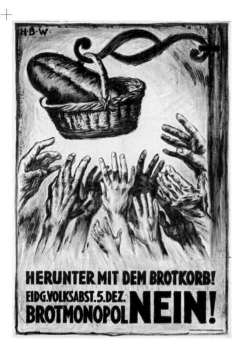

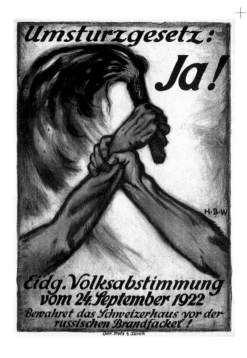

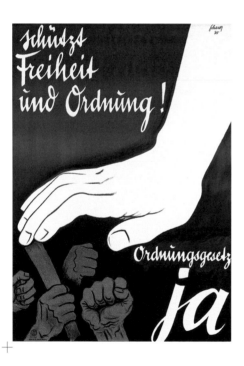

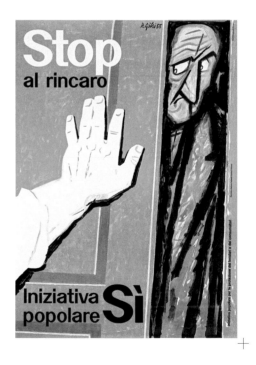

30 **Hans Beat Wieland**
Brotmonopol Nein!
1926

31 **Carl Scherer**
Ordnungsgesetz Ja
1934

32 **Hans Beat Wieland**
Umsturzgesetz: Ja!
1922

33 **René Gilsi**
Stop al rincaro / Iniziativa popolare Sì
1955

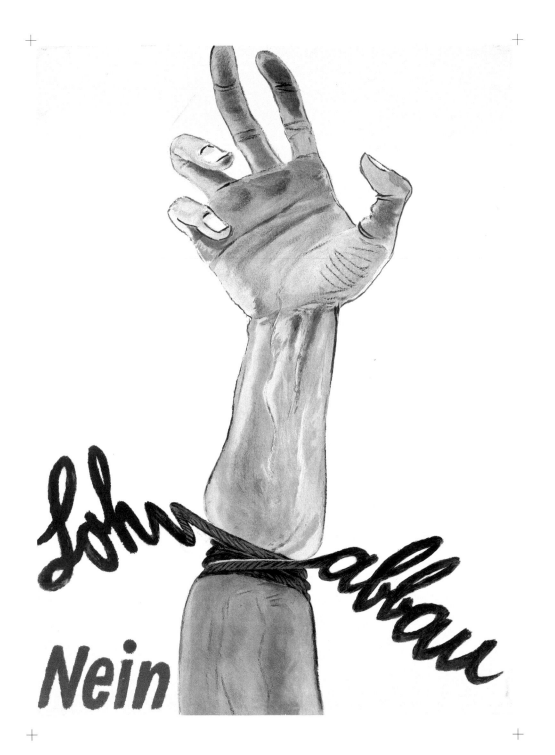

34 **Alois Carigiet**
Lohnabbau Nein
1933

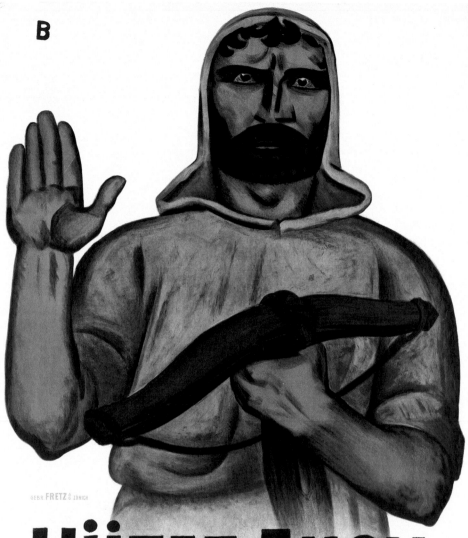

35 **Otto Baumberger**
Hütet Euch vor dem Versailler Völkerbund
1920

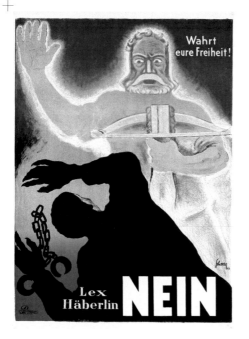

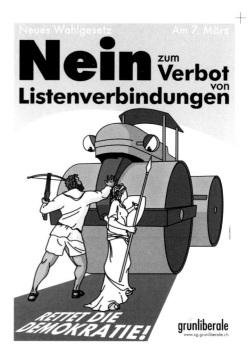

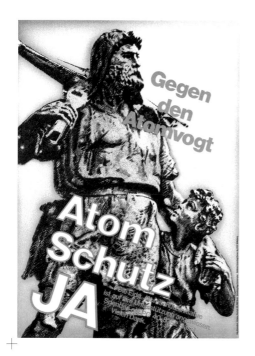

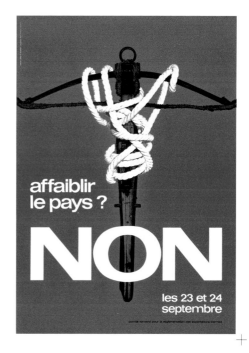

36 **Carl Scherer**
Wahrt Eure Freiheit! Lex Häberlin Nein
1922

37 **Hugo Schuhmacher**
Gegen den Atomvogt / Atomschutz Ja
1979

38 **Kilian Moser**
Nein zum Verbot von Listenverbindungen
2010

39 **Atelier Bataillard / Pierre Bataillard**
Affaiblir le pays? Non
1972

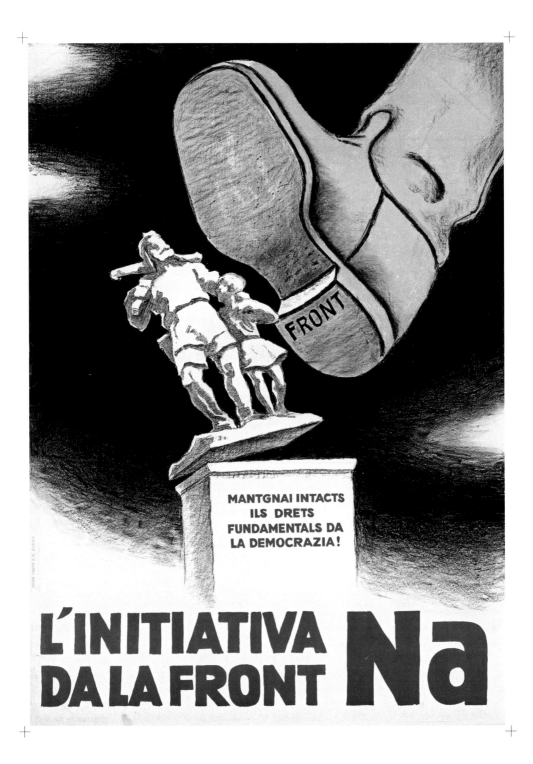

40 **Hugo Laubi**
L'initiativa da la front Na
1935

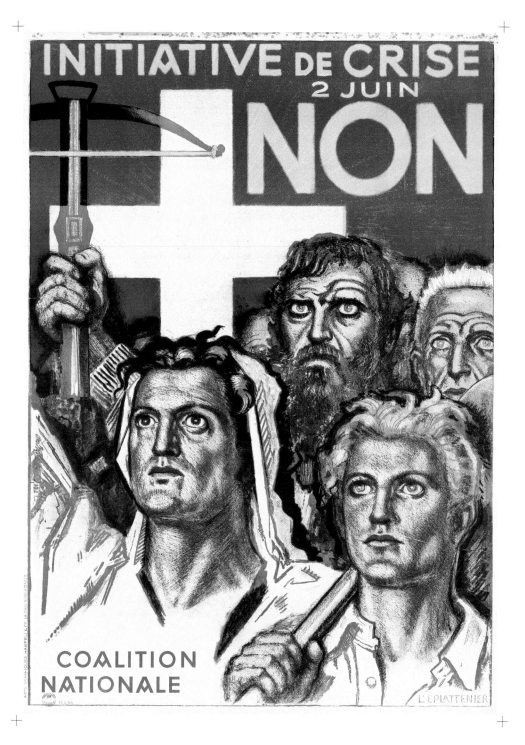

41 **Charles L'Eplattenier**
Initiative de crise Non
1935

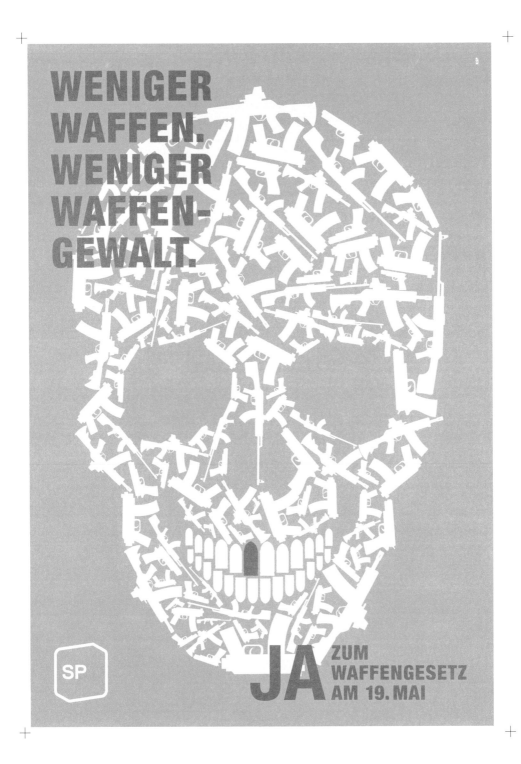

42 **KSP Krieg Schlupp Partner**
Ja zum Waffengesetz
2019

OUI
aux Casques bleus

**La Suisse
doit participer!**

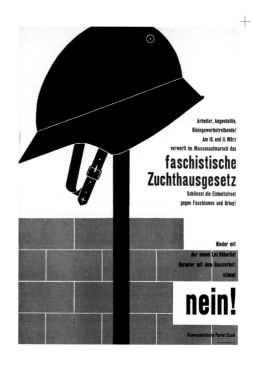

Arbeiter, Angestellte,
Kleingewerbetreibende!
Am 10. und 11. März
verwertt im Massenaufmarsch das

**faschistische
Zuchthausgesetz**

Schliesst die Einheitsfront
gegen Faschismus und Krieg!

Nieder mit
der neuen Lex Häberlin!
Herunter mit dem Gesslerhut!
stimmt

nein!

Kommunistische Partei Basel

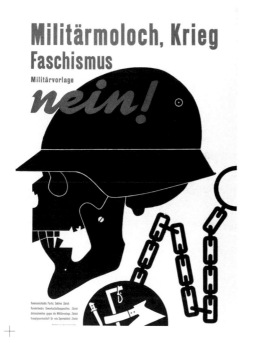

Militärmoloch, Krieg
Faschismus

Militärvorlage

nein!

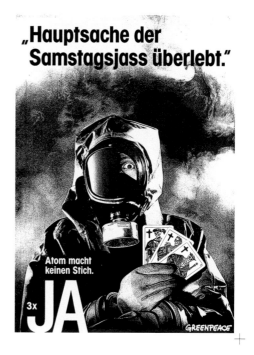

„Hauptsache der
Samstagsjass überlebt."

Atom macht
keinen Stich.

3x **JA**

GREENPEACE

43 **Anonym**
Oui aux Casques bleus
1994

44 **Theo Ballmer**
Militärmoloch, Krieg / Faschismus / Militärvorlage Nein!
1935

45 **Theo Ballmer**
Am 10. und 11. März verwerft im Massenaufmarsch
das faschistische Zuchthausgesetz, 1934

46 **Anonym**
Atom macht keinen Stich.
1990

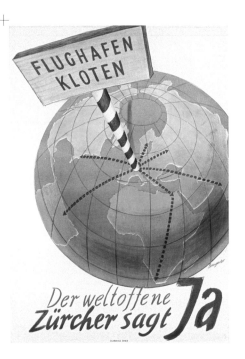

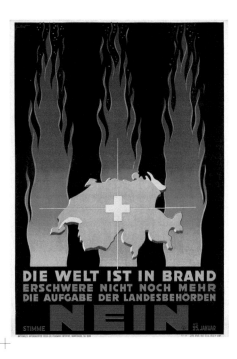

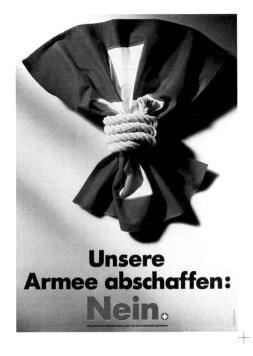

47 Atelier Rolf Bangerter / Rolf Bangerter
Flughafen Kloten / Der weltoffene Zürcher sagt Ja
1946

48 Noël Fontanet
Die Welt ist in Brand
1942

49 Anonym
Nein am 27. 9. zur überholten VKMB-Denner-Initiative,
weil sie unsere Landschaft aufs Spiel setzt., 1998

50 Anonym
Unsere Armee abschaffen: Nein.
1989

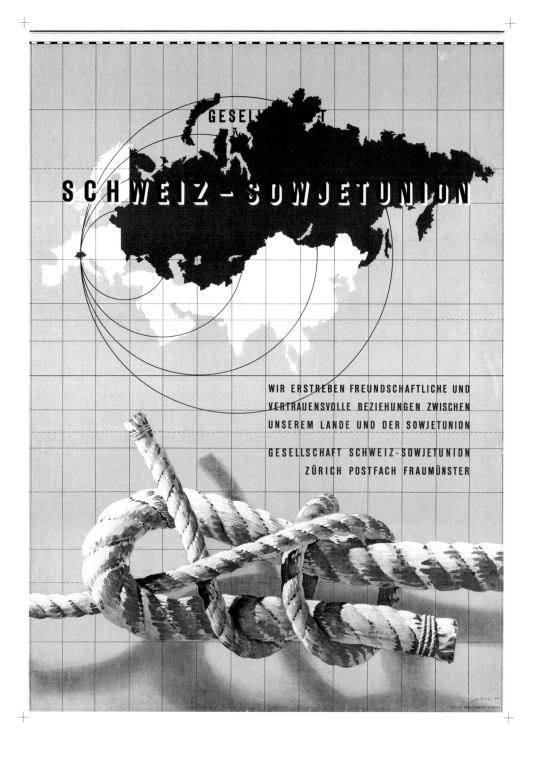

51 **Hans Erni**
Gesellschaft Schweiz-Sowjetunion
1945

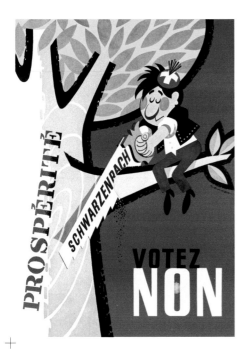

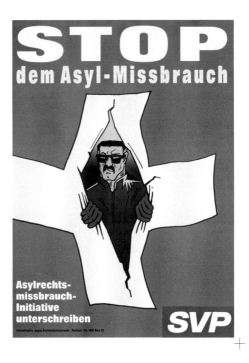

52 **Werbeagentur Edgar Küng**
Überfremdungsinitiative 3 Nein
1974

53 **Jean Leffel**
Prospérité / Schwarzenbach / Votez Non
1970

54 **Linard Biert**
Zur Initiative gegen die Überfremdung ein klares Nein
1970

55 **Goal AG für Werbung und Public Relations /**
Hans-Rudolf Abächerli
Stop dem Asyl-Missbrauch, 1999

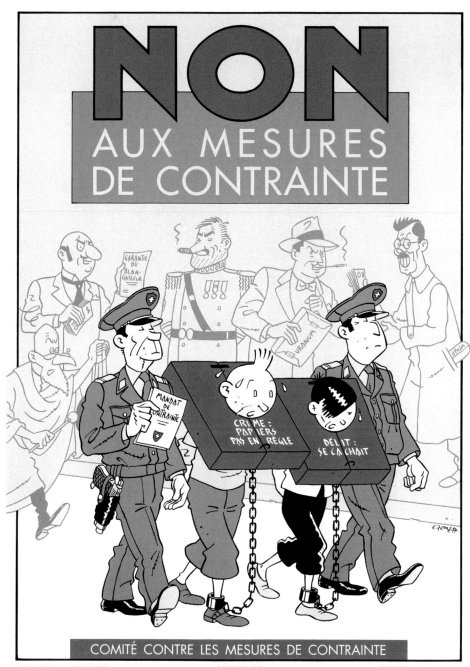

56 **Exem**
Non aux mesures de contrainte
1994

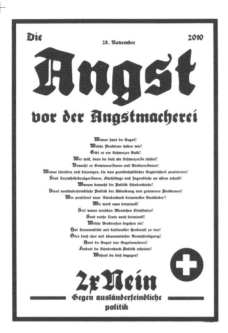

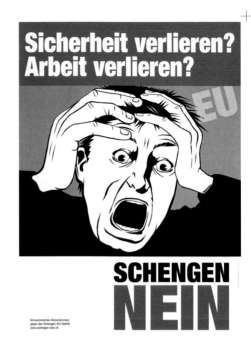

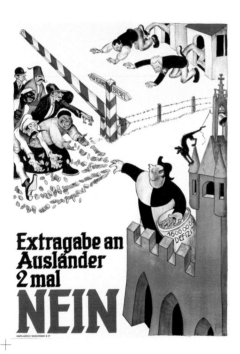

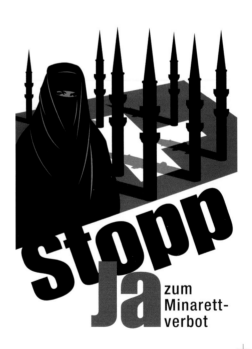

57 Eric Andersen
Die Angst vor der Angstmacherei
2010

58 Otto Jakob Plattner
Extragabe an Ausländer 2 mal Nein
1933

59 Goal AG für Werbung und Public Relations
Schengen Nein
2005

60 Goal AG für Werbung und Public Relations
Ja zum Minarettverbot
2009

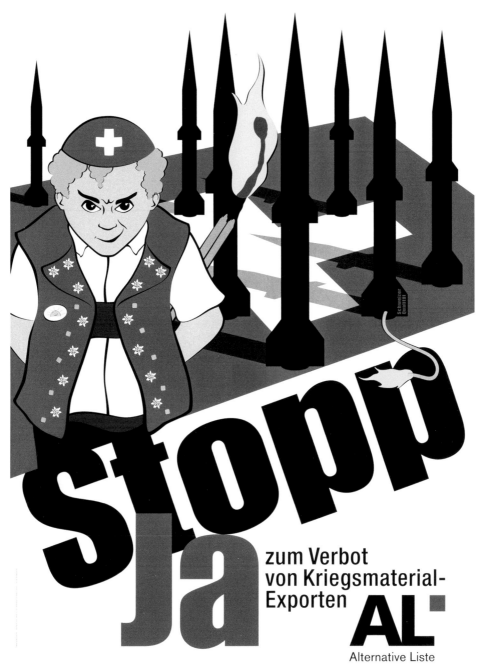

Stopp

Ja zum Verbot
von Kriegsmaterial-
Exporten **AL·**

Alternative Liste

61 **Typosalon / Christof Nüssli**
Ja zum Verbot von Kriegsmaterial-Exporten
2009

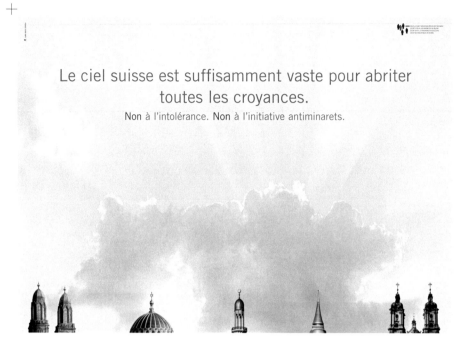

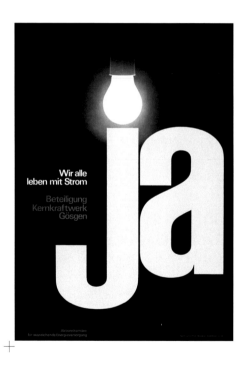

62 **Euro RSCG / Frank Bodin**
Le ciel suisse est suffisamment vaste pour
abriter toutes les croyances., 2009

63 **Fredy Prack, René Beuret**
Beteiligung Kernkraftwerk Gösgen Ja
1974

64 **Anonym**
Salviamo le nostre acque!
1992

"PICTURE GALLERY OF THE STREETS":
CAMPAIGN POSTERS IN TWENTIETH-CENTURY SWITZERLAND

Jakob Tanner

"In the great federal election campaign in the autumn of 1919, when the National Council was elected by proportional representation for the first time and each political group had to produce the best and most effective propaganda for its own prestige and to achieve or maintain future dominance in Switzerland, all the major parties used artistic posters and leaflets–the latest and most effective media of the day." This observation was made by Edwin Lüthy, director of the poster advertising firm Allgemeine Plakatgesellschaft Basel, in 1920.[1] The fact that the changeover from majority to proportional representation was adopted in October 1918 can in part be traced to the "framing" of the issue in a campaign poster that had illustrated the democratic slogan "Justice elevates a people" by contrasting the rule of the people with the power of capital 9.

THE FIRST WORLD WAR AS A CATALYST FOR POLITICAL PROPAGANDA

Political posters did not come out of the blue at the end of the First World War. The incubation period for commercial poster advertising was the fin de siècle, also known as the belle époque. A radically new poster style emerged in France. In Switzerland, posters established themselves around the turn of the century to promote tourism, entertainment culture, and advertising. Artists depicted landscapes, particularly lakes and mountains, as places of longing. At the same time, trademarked and branded products bucked the trend toward uniformity in industrial mass production. New labels and logos became popular alongside the older import labels and brands. They offered customers some orientation amid a bewildering range of goods.[2]

The German word *Reklame* (advertisement) also became popular during this time. Artists optimized the visual impact of their posters by simplifying, consolidating, and reducing familiar but suggestively arranged pictorial elements. From 1900 onward, they also made use of recent insights into the psychology of advertising. In the political arena, by contrast, this pictorial boom initially had little impact. Prior to 1914, the "Kulturkampf" (the culture war between the Catholic Church and the liberal state) and the intensifying class struggle were waged through the predominant medium of party newspapers; speeches, magazines, brochures, and leaflets were also used.

The First World War was to change this. It quickly grew into a global media spectacle, conducted as a "battle of concepts and visions, for sympathy and recognition." Professional "industries that supplied meaning" emerged in the warring countries and strengthened a cult of death and sacrifice for the fatherland. In this way, propaganda became "the flywheel of a war that gradually put the whole of society at its service."[3] Posters idealizing soldiers and weapons and promoting war bonds affirmed national unity. They served to shut down politics domestically in order to increase strength

1 Edwin Lüthy, *Das künstlerische politische Plakat in der Schweiz,* Basel 1920, pp. 6–7.
2 Claudia Steinfels, *Herbert Leupin 1916–1999, Werbegrafiker: Sein Leben, sein Werk, seine Bedeutung,* diss., University of Zurich, Zurich 2003; Daniela Flury-Schütz, *Der Blick auf die Landschaft: Landschaftsbilder auf den Tourismusplakaten Luzerns und der Region Vierwaldstättersee 1880–1960,* master's thesis, University of Zurich, Zurich 2007.
3 Michael Jeismann, "Propaganda," in: Gerhard Hirschfeld, Gerd Krumeich, and Irina Renz (eds.), *Enzyklopädie Erster Weltkrieg,* Paderborn 2009, pp. 198–209, here p. 202.

abroad. When, after more than four years, the war ended with economic exhaustion and the moral and institutional bankruptcy of states and empires, everything pointed to change. With food riots, social protests, reform demands, and revolutionary aspirations afoot, domestic political struggle resumed in all countries with the utmost intensity.

COMMERCIAL ADVERTISING AND POLITICAL POSTERS

This gave the political poster an enormous boost throughout Europe. Formal influences from futurism, expressionism, de Stijl, the Bauhaus, and agitprop became apparent in the years after the war. In Germany, the Social Democratic government recognized the new visual medium as a vehicle for social progress. "The Political Poster," a paper published "by official order" in 1919, emphasized the difference between the old capitalist and the emerging socialist style. The burnt-out, commercially aggressive, "modern poster ... shouts a word at us while pressing an object against our eyeballs" and is in its "logical consequence ... one-sided, loud, and brusque." In contrast, the increasingly influential "socialist advertising poster" was opening "a new chapter" of political communication, because it advertised "not a company, but an idea" and saw art as "communication from person to person!"[4]

Neutral Switzerland, too, was economically, socially, culturally, diplomatically, and ideologically involved in the increasingly total and global war. But while a profound upheaval occurred in Germany in November 1918, the Swiss federal state was marked by continuity. The high-flying hopes of reform among the labor and women's movements were dampened by the unconditional cessation of the general strike. Inspired by US advertising strategies, artists and graphic designers were less interested in a fundamental alternative to the commercial poster and instead transposed its principles to the competitively organized democracy of parties and associations. They thus created a popular "picture gallery of the streets" for the "broadest possible masses": "The artistic poster should and can, however, exert a telepathic grip on anyone aimlessly strolling or purposefully rushing by on the street. It should employ a concise slogan to push the brain in the desired political direction."[5]

However, the "omnipotence and inescapability" of the "good political artistic poster" did not appear absolute. Its broad emotional impact was limited by "the contest of ... the parties." In this economy of attention, Edwin Lüthy saw the same "advertising morality" at work as in the commercial realm: "Even the best artistic advertising will be of no use in the long run for bad, outmoded party goals that appear demagogic to a politically mature populace. Yes, as we all know, an excessively loud advertisement for a 'rotten thing'—once the initial deceptive bluff is over—only leads to growing mistrust among a sane public, which turns the intended purpose of the advertising into a negative one." Since all parties believed in their good cause, there was no limit to the proliferation of the poster. Here, too, the "socialist party ... as a member of the

4 *Das politische Plakat,* by official order, Charlottenburg 1919, p. 14.
5 Lüthy 1920, pp. 3–4. For Switzerland, an overview can be found in: Bruno Margadant, *"Für das Volk—Gegen das Kapital": Plakate der schweizerischen Arbeiterbewegung von 1919 bis 1973,* Zurich 1973; Willy Rotzler and Karl Wobmann, *Politische und soziale Plakate der Schweiz: Ein historischer Querschnitt,* Zurich 1985; see also Kai Artinger, "Das politische Plakat—Einige Bemerkungen zur Funktion und Geschichte", in idem (ed.), *Die Grundrechte im Spiegel des Plakats von 1919 bis 1999,* Berlin 2000, pp. 15–22.

opposition and a party of upheaval, impetuously in step with the spirit of the times," made pioneering use of the political poster 13, 18. But the Citizens' and Farmers' Bloc quickly followed suit and employed this "most timely and effective promotional tool"[6] 31, 32, 119.

Poster designer Otto Baumberger (1889–1961), who worked for business and political interests alike and to whom Switzerland owes some quite resilient subjects, stood like no other for this across-the-board use.[7] In 1920, Baumberger declared that the political poster must convey a brilliant idea: "It must ... be a 'hit,' plain and simple, tailored to the understanding of even the broadest masses, satirical, malicious, or sentimental; but always, a simple, clear idea that can be grasped by anyone must be aimed at their heads in a way that is absolutely compelling."[8] As much as Baumberger personally identified with the motifs on his posters, he proved to be just as flexible politically, handling commissions for the Social Democrats and the bourgeois liberals, among others.

WOMEN'S SUFFRAGE, THE LEAGUE OF NATIONS, AND THE CAPITAL LEVY IN FOCUS

In the 1920s, despite compromises and reforms, a shrill rhetoric of class struggle prevailed in Switzerland. Fear-mongering bourgeois posters, which associated socialism with chaos and destruction, contrasted with a left-wing strongman mentality that emphasized the physical and mental strength of working people. In June 1918, voters rejected the introduction of a direct federal tax: the proletarian in red trousers did not appeal to the sympathies of francophone Switzerland or conservative Catholics 103. Poster designer Hugo Laubi remarked self-critically: "With this, the socialist, who is mainly just out to blackmail here, has rather alienated people from other parties."[9] In October 1920, the image of a lazy, debt-burdened freeloader was just as counter-productive 101. The attempt to use this negative image to overturn the adoption of a forty-eight-hour work week at the Swiss Federal Transport Services failed.

Particularly memorable images emerged around the six cantonal referenda held between 1919 and 1921 to introduce women's suffrage. Female graphic artists such as Margrit Gams and Dora Hauth-Trachsler visualized the demand for gender equality in different ways 75, 76. The latter wrote that "only with complete clarity of conviction" would it be possible "to align colors, lines, surfaces, etc. with the underlying idea."[10] The prominent patriarchs of poster art countered this demand for emancipation with frightening images of women who sacrificed their femininity for political involvement 65 or with motifs of the protection of motherhood that were framed as an antithesis to the world of politics that had been exposed as a male domain 67.

The highlights of political poster advertising were the plebiscite on Switzerland's admission to the League of Nations in May 1920 (approved with 56 percent of the vote and a narrow majority of the cantons) and the vote on the popular initiative of the Social

6 All quotes from Lüthy 1920, pp. 5–6.
7 On the subject of "making" posters, Baumberger wrote in his diary in the late 1930s: "A work of art is created. A work of what's known as 'applied art' is MADE." Cited in Steinfels 2003, p. 46.
8 Baumberger, cited in Lüthy 1920, p. 8.
9 Laubi, cited in Lüthy 1920, p. 11.
10 Hauth-Trachsler, cited in Lüthy 1920, p. 9.

Democrats for a "one-time capital levy" in December 1922 (crushed with 87 percent voting "no"). The money that flowed into both campaigns reached peak levels, and political posters were put up in record numbers, resulting in a comparatively high voter turnout. Both sides drew upon the store of national images: Swiss mountains, William Tell, the Rütli oath, Alpine people, Helvetia 35, 116. In addition, a terrific campaign of fear was launched against the capital levy with rats, clawing hands, red demagogues, gravediggers, and scenarios of gloom and doom 14, 100, 104.

In the interwar period, commercial and political advertising conveyed strikingly contradictory messages. While the former, referencing the "Swiss week" and the crossbow as hallmarks of quality, was committed to national economic patriotism and banked on making Switzerland's distinctive characteristics stand out in public perception, the political campaigns expressed democratic pluralism and the country's continuing internal divisions despite the emergence of consociational democracy 6, 12, 36, 40, 41.

HELVETO-CENTRIC ICONOGRAPHIES

In the period after the Second World War, political posters flourished once again, driven by stylistic innovations. The arsenal of national myths now proved to be a permanent fixture. An iconography of international dependence, global networking, and international solidarity could hardly develop under the imaginary protective shield of the nation. In early 1945, a poster for the Switzerland–Soviet Union Society, designed by artist Hans Erni, was banned 51. In a poster for the 1946 expansion of Kloten Airport in the canton of Zurich, an oversized signpost covers Switzerland, which was being called out for its economic collaboration with the Nazi regime 47. Even the visual revolt of the 1968 peace movement did little to change this national self-centeredness.

In the late 1960s, political scientist Erich Gruner diagnosed a crisis in party politics. He criticized both anti-democratic talk of the "terror of party-led opinion formation" and the technocratic belief that political culture could be replaced by experts and a computer-assisted "striving for objectiveness." Gruner noted a profound shift in the media, coupled with the growing appeal of pop culture "heroes" from sports, movies, and beat music. He attributed the "call to opposition" to the idea that voting and election campaigns had degenerated into sham contests and media farces: "The parties still appear in the costume of their historical ideologies, but this masquerade robs them of any credibility."[11] Under these conditions, sales promotion and political mobilization function in a similar way: the communication of alternative models of society yields to the sampling of voters' opinions, which are then filtered along party lines and projected back into the public sphere via posters.

Swiss posters reveal a stagnation in Swiss exceptionalism beyond the Cold War. Although there were repeated attempts to break out of the cage of national iconography 8, 42, 66, these did not have a lasting effect. With the rise of the Swiss People's

11 Erich Gruner, *Die Parteien in der Schweiz,* Bern 1969, pp. 247 and 256. See also Zoé Kergomard, *Wahlen ohne Kampf? Schweizer Parteien auf Stimmenfang, 1947–1983,* Basel 2020.

Party (SVP) in the 1990s, the "tremendous impact of the pictorial poster on the masses" (already conjured up back in 1919) acquired a new virulence. The sheer volume of poster campaigns by the nationalist right became a political issue and reaffirmed a demand for financial transparency. In addition, the SVP continued to test the limits of what could be shown and provoked scandals in the media with its racist depictions 55, 93, 94.

Counterstrategies attempted "hostile takeovers"–for example, by reinterpreting ominous silhouettes of minarets as Helvetic missile exports 60, 61. Demagogic motifs appealing to national egotism and xenophobia are now increasingly being countered by plain posters bearing slogans and texts that make strong statements rather than visual subjects the focus of mass communication 3, 57, 130–134. The emergence and contradictory effects of social media are reinforcing older trends while also creating new conditions. In the volatile imagery of the twenty-first century, political advertising is oscillating between democratic crowdfunding and large capitalist donations, generating revenues that keep the political picture gallery going.

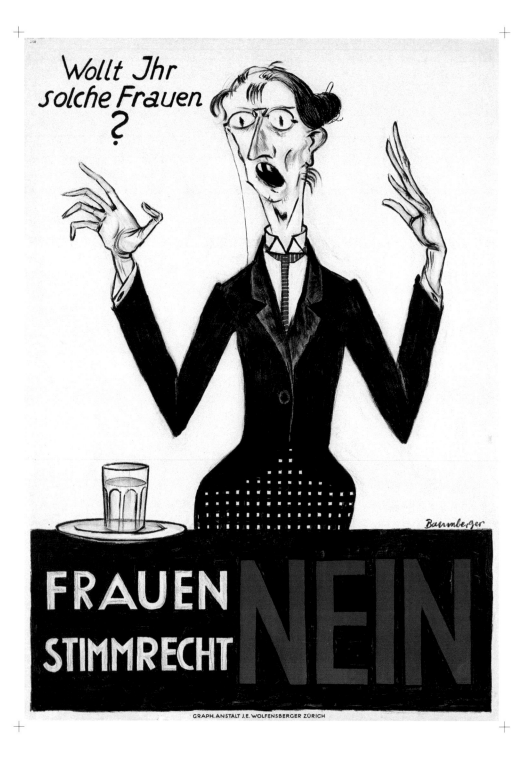

65 **Otto Baumberger**
Frauenstimmrecht Nein
1920

EIN FREIES VOLK

BRAUCHT

FREIE FRAUEN

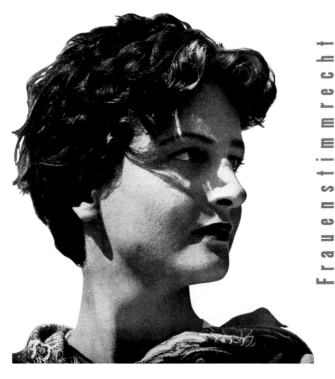

Partei der Arbeit, Basel-Stadt

Frauenstimmrecht

JA

66 **Atelier Eidenbenz / Hermann Eidenbenz**
Frauenstimmrecht Ja
1946

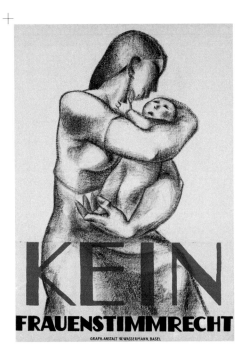

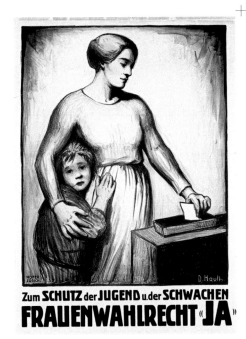

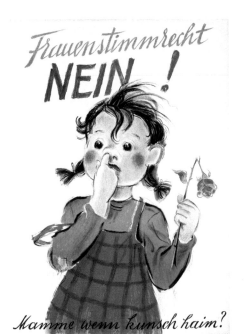

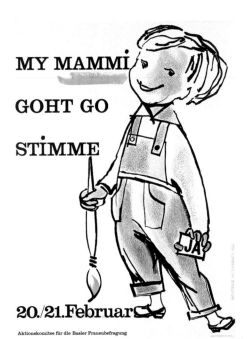

67 **Niklaus Stoecklin**
Kein Frauenstimmrecht
1920

68 **Hugo Laubi**
Frauenstimmrecht Nein!
1946

69 **Dora Hauth-Trachsler**
Zum Schutz der Jugend u. der Schwachen /
Frauenwahlrecht «Ja», 1920

70 **Beatrice Afflerbach**
My Mammi goht go stimme
1954

50

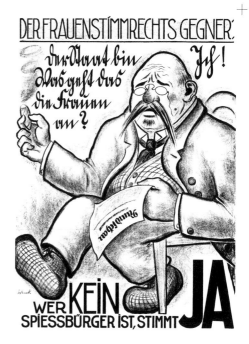

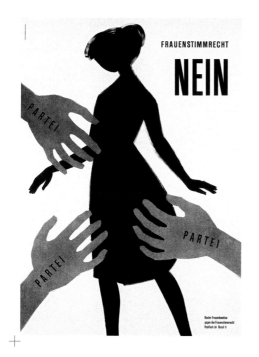

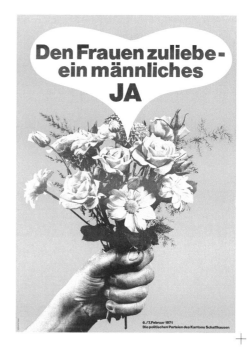

71 **Jürg Spahr**
Frauenstimmrecht Ja
1959

72 **Anonym**
Frauenstimmrecht Nein
1959

73 **Wilhelm Wenk**
Wer kein Spiessbürger ist, stimmt Ja
1946

74 **Anonym**
Den Frauen zuliebe – ein männliches Ja
1971

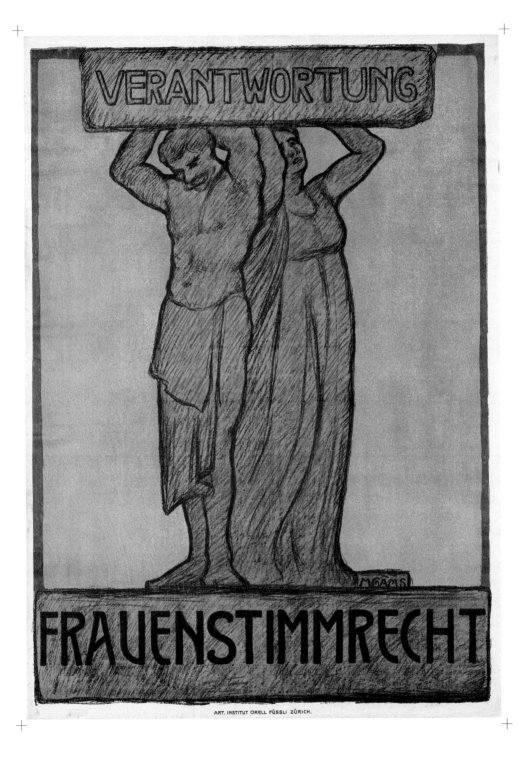

ART. INSTITUT ORELL FÜSSLI ZÜRICH.

75 **Margrit Gams**
Verantwortung / Frauenstimmrecht
1920

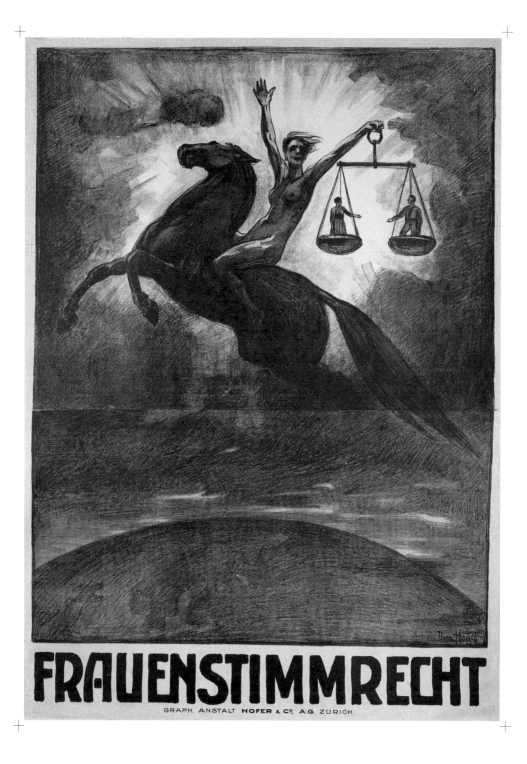

76 **Dora Hauth-Trachsler**
Frauenstimmrecht
1920

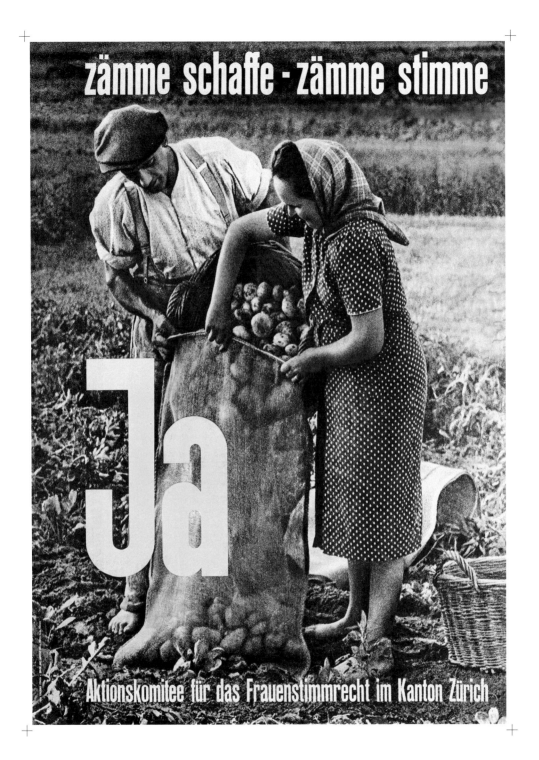

77 **Richard Paul Lohse**
Zämme schaffe – zämme stimme
1947

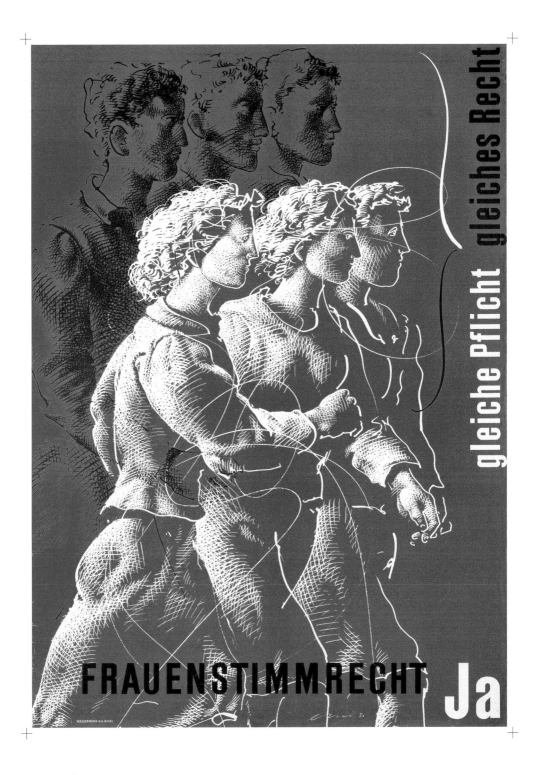

78 **Hans Erni**
Gleiche Pflicht / Gleiches Recht
1946

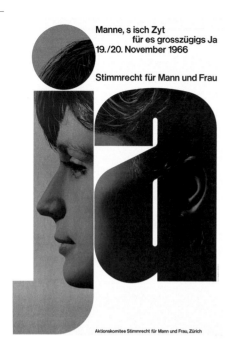

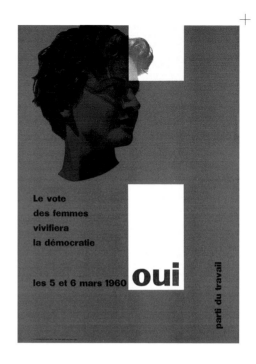

79 **Anonym**
Manne, s'isch Zyt für es grosszügigs Ja
1966

80 **Anonym**
Darum politisches Frauenstimmrecht Nein
1959

81 **Charles Affolter**
Le vote des femmes vivifiera la démocratie
1960

82 **Anonym**
Zusammenarbeit für Familie und Staat Ja
1959

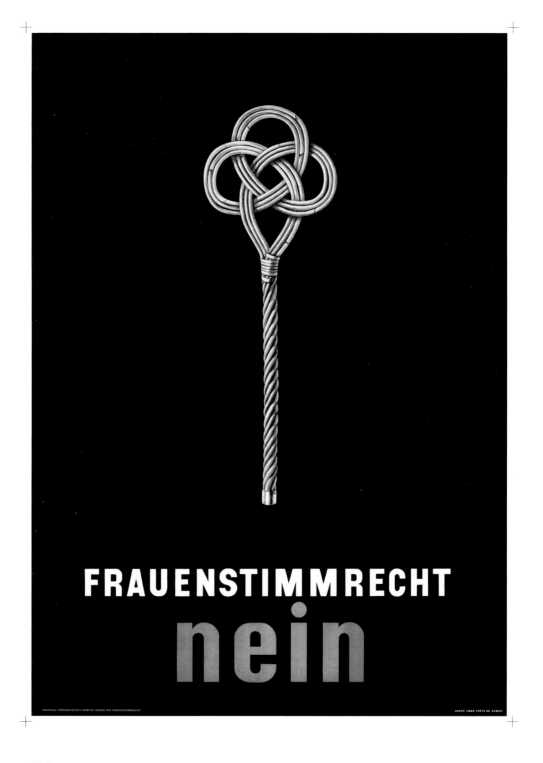

83 **Anonym**
Frauenstimmrecht Nein
1946

DIE STIMME DER FRAU
Bettina Richter

«Manche betrachten den Feminismus als einen grossen Fortschritt, andere als einen Fluch. Die wenigsten nehmen ihn mit der Seelenruhe derer auf, die wissen, dass die Dinge überhaupt nicht durcheinander geraten, bloss weil Frauen in einer Bank arbeiten, eine leitende Stelle in der öffentlichen Verwaltung innehaben und hie und da auf die Strasse gehen, um ein Zettelchen in eine Urne zu werfen. (…) Ohne zu glauben, dass wir Frauen die Welt erneuern und die Jahrhunderte verblüffen müssten, bin ich der Ansicht, dass die Stimme der Frau in vielen Diskussionen fehlt und dass ihr Denken zum Ausgleich der universalen Gerechtigkeit beitragen wird.»[1]

Dieses Zitat stammt aus dem einzigen Text, in dem sich die avantgardistische Dichterin und Schriftstellerin Alfonsina Storni (1892–1938) auf die Schweiz bezieht. Geboren im Tessin, wanderte sie mit ihren Eltern 1896 nach Argentinien aus. Von 1919 bis 1920 betreute Storni in der argentinischen Zeitschrift La Nota die Kolumne Feminidades und äusserte sich dort in kritischironischem Ton zu Frauenfragen. 1919 schrieb sie obige Zeilen – im selben Jahr, als erstmals auf kantonaler Ebene das Frauenstimmrecht an die Urne kam.

Bereits im späten 19. Jahrhundert kämpften auch Schweizer Frauen in verschiedenen Bewegungen und Vereinen um ihre juristische, gesellschaftliche und wirtschaftliche Gleichstellung. Nach dem Ersten Weltkrieg eroberte das Thema die offizielle politische Agenda. Zwischen 1919 und 1959 entschied das männliche Stimmvolk in verschiedenen Kantonen und Halbkantonen rund 25-mal über das weibliche Stimmrecht, immer jedoch mit negativem Ergebnis. Erst 1971 konnten die Frauen triumphieren.

Die Plakate für und gegen das Frauenstimmrecht reflektieren die gegensätzlichen Weltsichten zu diesem Thema, die Storni mit den Worten «Fortschritt» und «Fluch» knapp zusammenfasst. Pro-Plakate aus dem Jahr 1920, darunter auch solche von Gestalterinnen, zeigen klassische Rollenzuschreibungen und Geschlechterbilder, argumentieren jedoch mit der Rechtsgleichheit. Dora Hauth-Trachslers Mutter verrät die ihr zugewiesene Rolle keineswegs, wenn sie «ein Zettelchen in eine Urne wirft» 69. Nicht von ungefähr wird aber nicht ihr, sondern Otto Baumbergers Plakat aus dem gleichen Jahr bis heute häufig zitiert. In seiner Darstellung «entweiblicht» die Politik jede Frau, macht sie zur unattraktiven Hyäne und gefährdet die traditionelle Gesellschaftsordnung 65. Baumbergers Botschaft, gerichtet an beide Geschlechter, kam an: Löste sie bei Frauen die Angst aus, als begehrenswerte Partnerin an Wert zu verlieren, so bei Männern jene vor radikaler Veränderung und dem Verlust eigener Privilegien. Denn tatsächlich griff Baumberger mit seiner Abbildung der Zeit weit voraus, zeigt sein Plakat eben nicht einfach eine Frau, die ihre Stimme abgibt, sondern vielmehr eine Frau am Rednerpult, die sich aktiv einmischt und somit mitbestimmt.

Über Jahre hinweg blieb die Argumentationsstrategie der Gegner des Frauenstimmrechts dieselbe: Frauen vernachlässigen ihre eigentliche Bestimmung als Ehefrau, Mutter und Hausfrau, wenn sie sich um politische Belange kümmern. Donald Bruns ikonisches Plakat von 1946 leistet eine meisterhafte visuelle Übersetzung dieser Rhetorik. Ohne eine Frau oder ein Kind abzubilden, spricht der überdimensionale Schnuller – wiedergegeben in der fotografischen Detailtreue des Sachplakats – für sich: Auf seinem Sauger hat sich eine Fliege niedergelassen 1. Dagegen hatten die Befürworter des Frauenstimmrechts einen schweren Stand, deren Parolen «Zämme schaffe, zämme stlmme» oder «Gleiche Pflicht, gleiches Recht» nur mässig beeindruckten 77, 78. Am meisten überzeugt ein Plakat der Partei der Arbeit (PdA), gestaltet von Hermann Eidenbenz – wohl nicht zuletzt auf Drängen seiner Frau Lotti Eidenbenz-Christoffel, die in der PdA für das Frauenstimmrecht eintrat 66. Bei der dargestellten jungen Frau handelt es sich um ein Stil der Schauspielerin Lotti Geissler aus dem Film S'Vreneli am Thunersee. Ihr selbstbewusstes Porträt verkörpert ein neues, modernes Vorbild, eine Frau, die ganz ohne Mann und Kind auskommt. Die innovative grafische Gestaltung des Entwurfs unterstreicht das progressive Anliegen. 1960 wurde Geisslers Foto erneut verwendet, was den Erfolg des Plakats in seiner Zeit belegt. Es ist eine traurige Ironie, dass Geissler kurz nach der Abstimmung von 1946 Friedrich Dürrenmatt heiratete und die eigene Karriere seinetwegen aufgab.

In den 1950er-Jahren setzte ein allmählicher Gesinnungswandel ein, nicht zuletzt durch die steigende Präsenz der Frau in der Arbeitswelt. 1959 gelangte das Frauenstimmrecht erstmals auf nationaler Ebene zur Abstimmung, während fast alle Länder Mitteleuropas das Wahlrecht für beide Geschlechter bereits nach dem Ersten Weltkrieg eingeführt hatten. Auf Plakaten aus diesem Jahr wird wiederholt der Mann umschmeichelt, dem schliesslich die Entscheidungshoheit in der Sache gehörte, war doch nur er abstimmungsberechtigt. Sein Ja an der Urne, so der Appell, soll, wenn nicht aus rationalen Gründen, doch wenigstens aus Ritterlichkeit erfolgen. Die Frau dankt es ihm mit einem Kuss 71. Damit erfährt aber auch der Diskurs über grundlegende Menschenrechte eine beispiellose Banalisierung.

Als 1971 das Frauenstimmrecht endlich angenommen wurde, fand sich im Vorfeld in den Strassen kein einziges gegnerisches Plakat mehr. Allerdings folgt die Botschaft des einzigen damaligen Ja-Plakats in der Plakatsammlung des Museum für Gestaltung Zürich derselben paternalistischen Rhetorik wie in den Plakaten von 1959 74. Immerhin aber wurde damit ein Etappensieg auf dem Weg zur Gleichstellung von Mann und Frau in der Schweiz erreicht. Dass noch längst nicht alle Kämpfe ausgefochten sind, davon zeugte der Frauenstreiktag vom 14. Juni 1991, der im Jahr 2019 eine mächtige Neuauflage erlebte.

1 Alfonsina Storni, «Die Auserwählten», Kolumne in La Nota, 18. April 1919, zit. in: dies., Meine Seele hat kein Geschlecht. Erzählungen, Kolumnen, Provokationen, Zürich 2013, S. 135.

THE VOICE OF WOMEN
Bettina Richter

"Some see feminism as a great advance, others as a curse. Few embrace it with the serenity of those who realize that one by no means precludes the other simply because women work at a bank, hold a senior position in public administration, and now and then take to the streets to toss a piece of paper into a ballot box…. Without believing that we women have to transform the world and amaze the centuries, I am of the opinion that the voice of women is absent from many discussions and that their thinking will help balance universal justice."[1]

This quote comes from the only text in which avant-garde poet and writer Alfonsina Storni (1892–1938) referred to Switzerland. Born in Ticino, she emigrated with her parents to Argentina in 1896. From 1919 to 1920, Storni edited a column called "Feminidades" in the Argentinian magazine *La Nota*, in which she offered a critical and ironic take on women's issues. She wrote the above words in 1919, the same year that women's suffrage was first put to a vote in Switzerland at the cantonal level.

By the late nineteenth century, Swiss women were fighting for legal, social, and economic equality in various movements and associations. After the First World War, the issue captured the official political agenda. Between 1919 and 1959, the male electorate in various cantons and half-cantons voted some twenty-five times on whether to allow women's suffrage, but always with negative results. It was not until 1971 that women finally triumphed.

The posters for and against women's suffrage reflect the opposing views on this issue, which Storni neatly encapsulated in the words "advance" and "curse." Pro-suffrage posters from 1920, including those by female designers, depict traditionally defined roles and gender stereotypes, but argue in favor of equal rights. Dora Hauth-Trachsler's mother by no means betrays the role assigned to her when she "tosses a piece of paper into a ballot box" 69. It is no coincidence, though, that Otto Baumberger's poster from the same year–not hers–continues to be referenced today. In his depiction, politics "defeminizes" women, turning them into unattractive harpies and endangering the traditional social order 65. Baumberger's message, addressed to both sexes, hit home, causing women to fear losing their value as desirable partners, and men to fear radical change and the loss of their own privileges. Baumberger's illustration was in fact far ahead of its time; his poster does not simply show a woman casting her vote, but rather a woman at the podium who actively intervenes and thus has a say in the decision-making process.

For years, the opponents of women's suffrage maintained the same line of argumentation: that women neglect their true calling as wives, mothers, and housewives when they become concerned with political issues. Donald Brun's iconic poster from 1946 provides a masterful visual interpretation of this rhetoric. Without depicting a woman or a child, the oversized pacifier–reproduced on the poster in photographic detail–speaks for itself: a fly has settled on the artificial nipple 1. The advocates of women's suffrage had a difficult time countering this, as their slogan "Zämme schaffe, zämme stimme" ("Work together, vote together") and "Gleiche Pflicht, gleiches Recht" ("Equal duties, equal rights") did not make much of an impression on people 77, 78. The most convincing poster was one by the Party of Labor, designed by Hermann Eidenbenz, probably not least at the urging of his wife Lotti Eidenbenz-Christoffel, who advocated women's suffrage from within the party 66. The young woman on the poster is actress Lotti Geissler in a still from the movie *S'Vreneli am Thunersee.* In this self-confident portrait, she embodies a new, modern role model, a woman who does just fine without a husband and child. The innovative graphic design emphasizes this progressive cause. Geissler's photo was used again in 1960, proving how successful the poster was in its time. It is a sad irony that shortly after the 1946 vote, Geissler married playwright Friedrich Dürrenmatt and gave up her own career for his sake.

Attitudes gradually changed in the 1950s, not least due to the increasing presence of women in the workplace. Women's suffrage was put to the vote for the first time at the national level in 1959, in contrast to nearly all other central European countries, which had already introduced voting rights for both sexes after the First World War. Posters from 1959 repeatedly flattered the men who ultimately had the power to decide the matter, since only they were entitled to vote. Their consent at the ballot box, so the appeal went, should be given, if not for rational reasons, then at least out of chivalry. Women thanked them with a kiss 71. But with this approach, the discussion of fundamental human rights also acquired an unprecedented level of banality.

When women's suffrage was finally adopted in 1971, not a single opposing poster was found on the streets prior to the vote. However, the message conveyed by the only "yes" poster from that time in the poster collection of the Museum für Gestaltung Zürich employed the same paternalistic rhetoric as the posters from 1959 74. Nevertheless, this was a major victory on the road to equality between men and women in Switzerland. The fact that there are still many battles to be fought was evidenced by the Women's Strike Day of June 14, 1991, which saw a tremendous reprise in 2019.

1 Alfonsina Storni, "Die Auserwählten," *La Nota,* April 18, 1919, cited in idem, *Meine Seele hat kein Geschlecht: Erzählungen, Kolumnen, Provokationen,* Zurich 2013, p. 135.

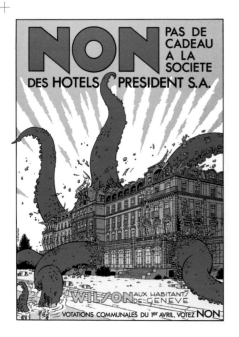

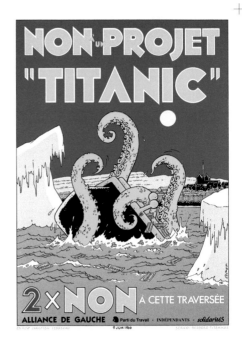

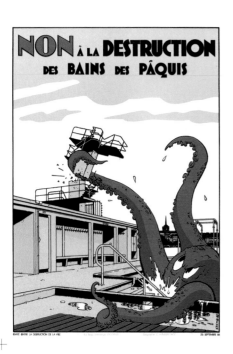

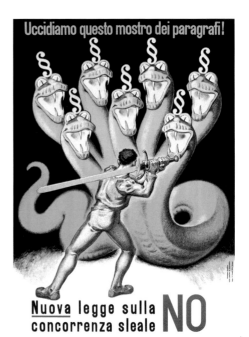

84 **Exem**
Non / Pas de cadeau à la Société des Hôtels
Président S.A., 1990

85 **Exem**
Non à la destruction des Bains des Pâquis
1988

86 **Exem**
Non à un projet «Titanic»
1996

87 **Carl Moos**
Nuova legge sulla concorrenza sleale No
1944

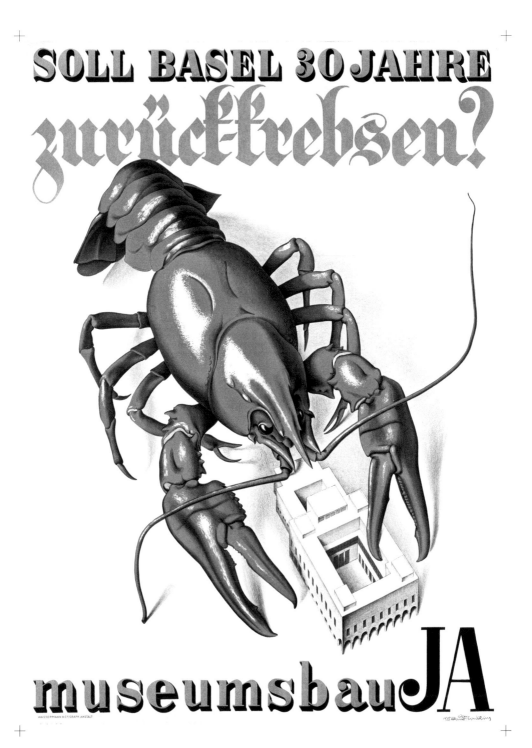

88 **Niklaus Stoecklin**
Museumsbau Ja
1932

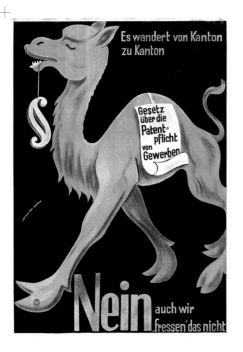

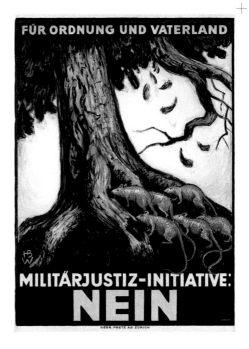

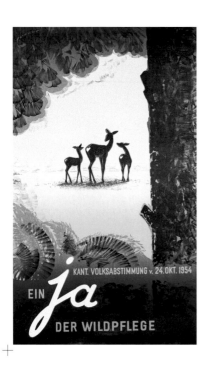

89 **Karl Schlegel**
Gesetz über die Patentpflicht von Gewerben
1936

90 **Martin Peikert**
Ein Ja der Wildpflege
1954

91 **Hans Beat Wieland**
Militärjustiz-Initiative: Nein
1921

92 **Reumann Atelier Carton / Helge Reumann**
Un petit effort pour demain
1987

93 **Goal AG für Werbung und Public Relations**
Ausschaffungsinitiative Ja
2010

94 **Goal AG für Werbung und Public Relations**
Freipass für alle? Nein
2009

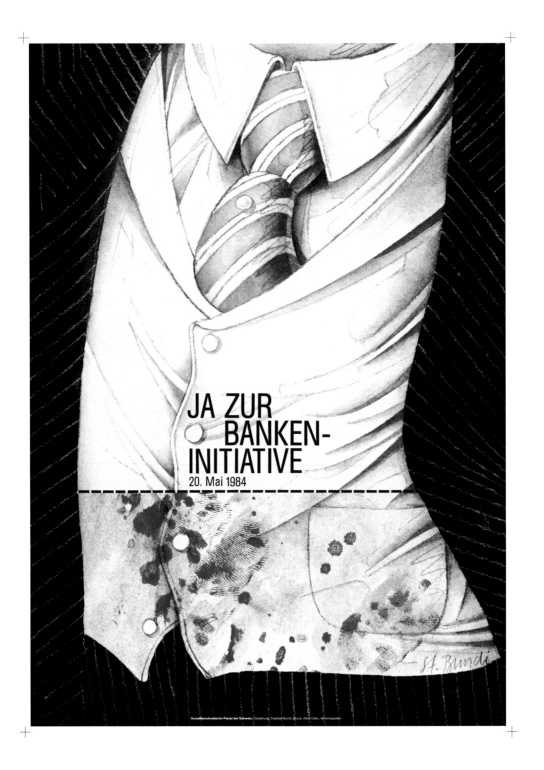

**JA ZUR
BANKEN-
INITIATIVE**
20. Mai 1984

95 **Stephan Bundi**
Ja zur Bankeninitiative
1984

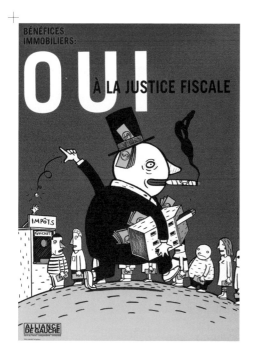

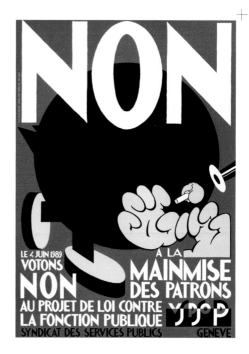

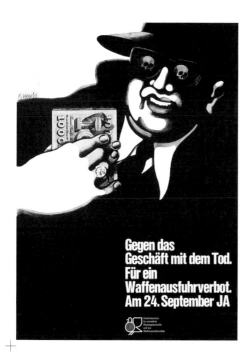

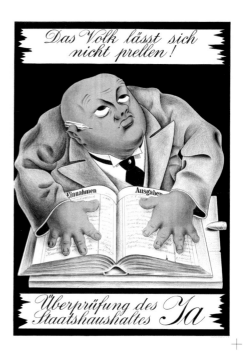

96 **Elvis Studio graphisme et illustrations /
Helge Reumann**
Bénéfices immobiliers: Oui à la justice fiscale
1998

97 **Stephan Bundi**
Für ein Waffenausfuhrverbot., 1972

98 **Les Studios Lolos / Aloys**
Non à la mainmise des patrons
1989

99 **Niklaus Stoecklin**
Überprüfung des Staatshaushaltes Ja
1939

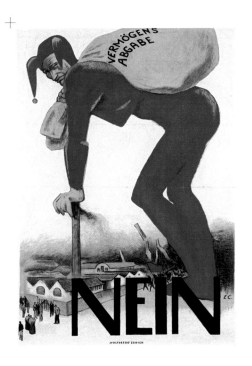

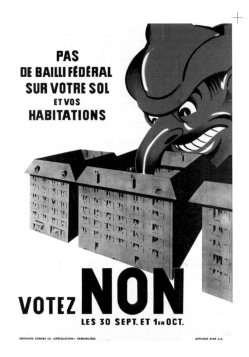

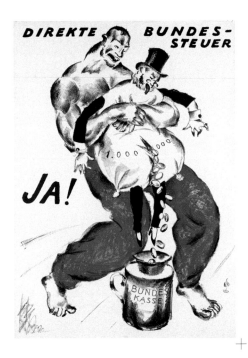

100 **Emil Cardinaux**
Vermögensabgabe Nein
1922

101 **Atelier Häusler**
Nein
1920

102 **Anonym**
Pas de bailli fédéral sur votre sol et vos habitations
1950

103 **Hugo Laubi**
Direkte Bundessteuer Ja!
1918

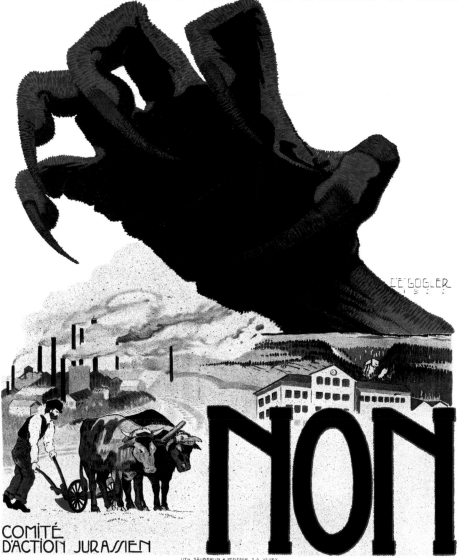

104 **Charles Edouard Gogler**
Confiscation de la propriété Non
1922

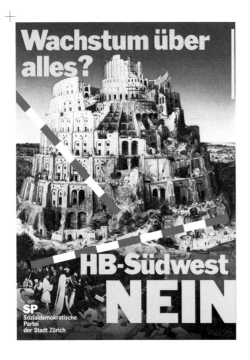

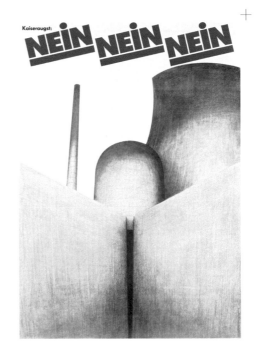

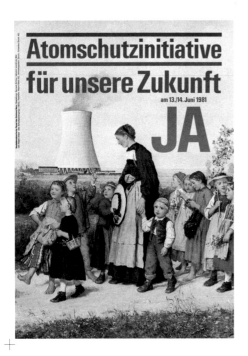

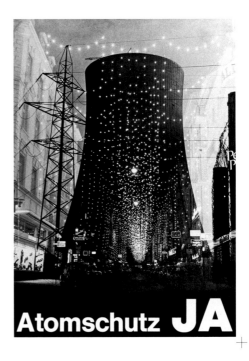

105 **Raymond Naef**
HB-Südwest Nein
1988

106 **Bernard Schlup**
Atomschutzinitiative für unsere Zukunft Ja
1981

107 **Born / Lutz / Münger**
Kaiseraugst: Nein
1979

108 **Jürg Stauffer**
Atomschutz Ja
1979

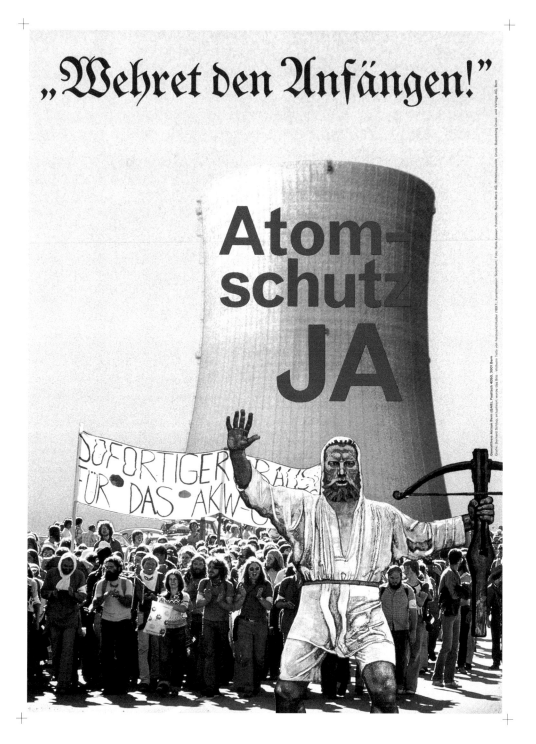

Gesamtverein Atrium Bern (GAB), Postfach 4050, 3001 Bern · Grafic: Bernard Schlup, erhältlich wurde das Bild · Wilhelm Tell: von Ferdinand Hodler (1897), Kunstmuseum Solothurn, Foto: Hans Kaiser, Fotolitho: Repro Merri AG, Mittelstrasse, Druck: Benteli AG, Mittelstrasse, Druck- und Verlags-AG, Bern

109 **Bernard Schlup**
Atomschutz Ja
1979

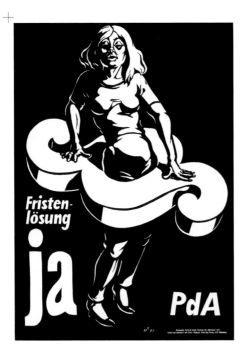

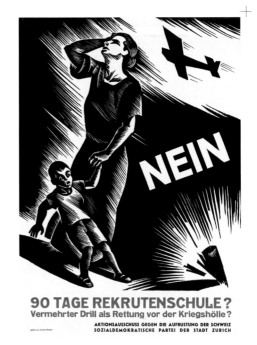

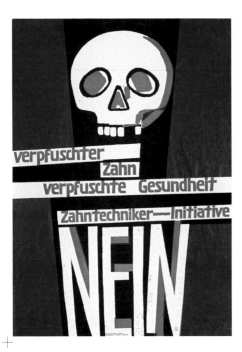

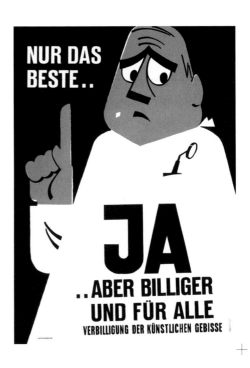

110 **Heiri Strub**
Fristenlösung Ja
1977

111 **Ernst Keller**
Zahntechniker-Initiative Nein
1946

112 **Aldo Patocchi**
90 Tage Rekrutenschule? Nein
1935

113 **Anonym**
Verbilligung der künstlichen Gebisse
1960

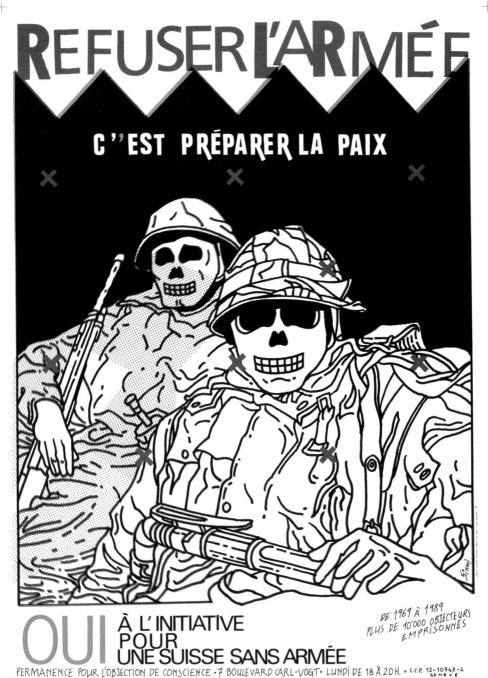

114 **Simon**
Oui à l'initiative pour une Suisse sans armée
1989

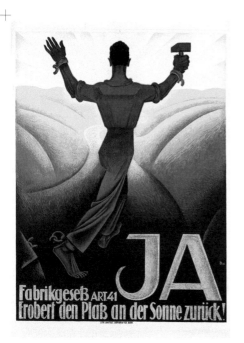

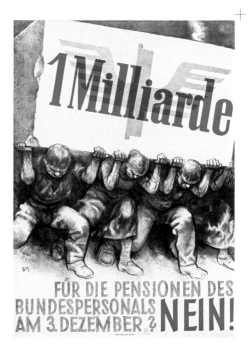

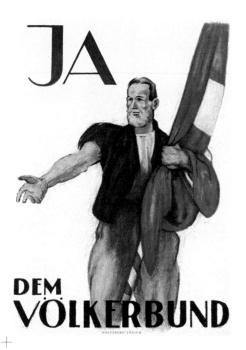

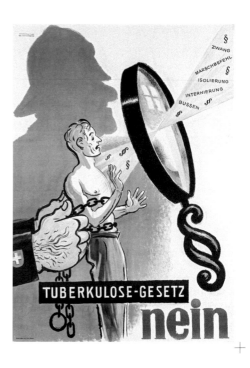

115 **Fred Stauffer**
Fabrikgesetz Art. 41 Ja
1924

116 **Emil Cardinaux**
Ja dem Völkerbund
1920

117 **Otto Baumberger**
1 Milliarde für die Pensionen des Bundespersonals
am 3. Dezember? Nein!, 1939

118 **Hugo Laubi**
Tuberkulose-Gesetz Nein
1949

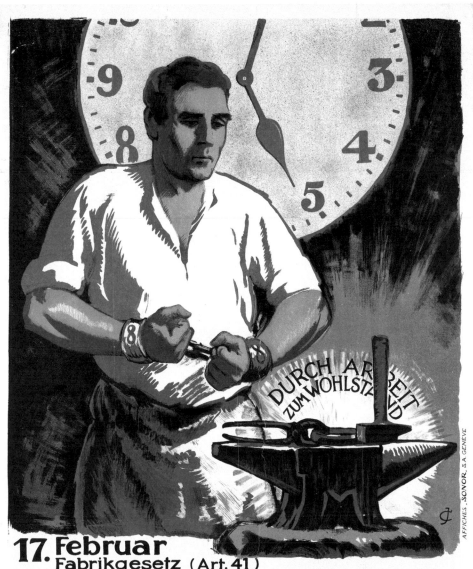

119 **Jules-Ami Courvoisier**
Lasst mich arbeiten, stimmt: Ja!
1924

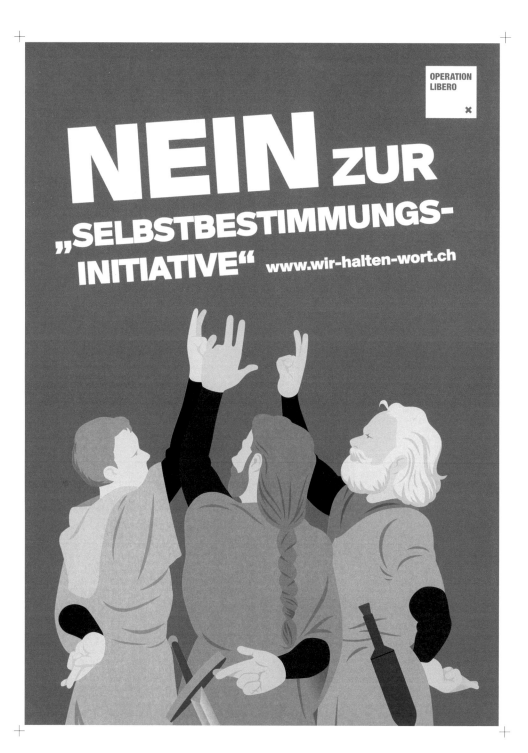

120 **Anonym**
Nein zur «Selbstbestimmungsinitiative»
2018

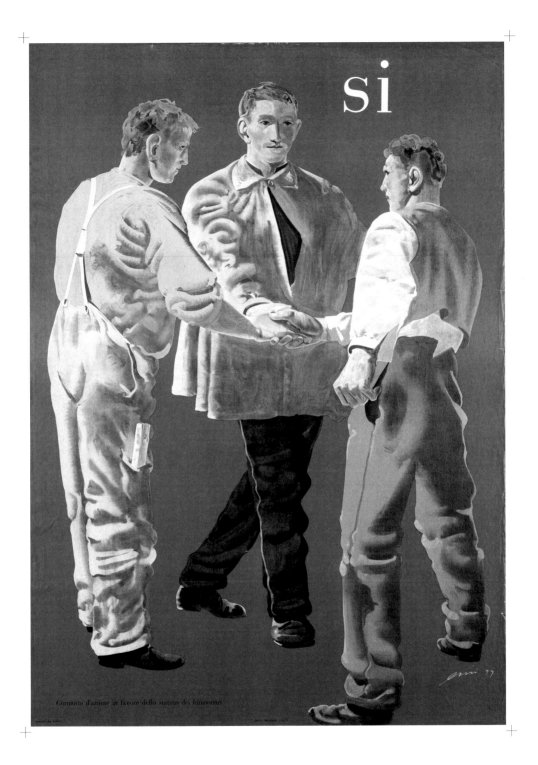

121 **Hans Erni**
Sì
1949

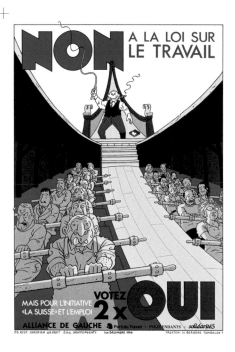

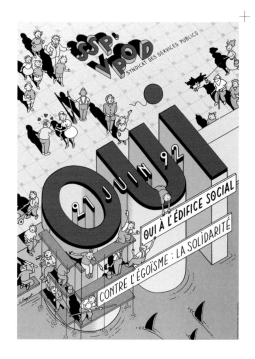

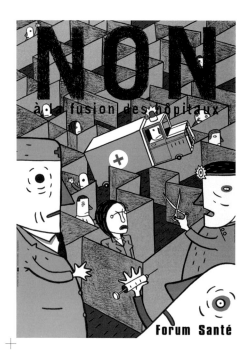

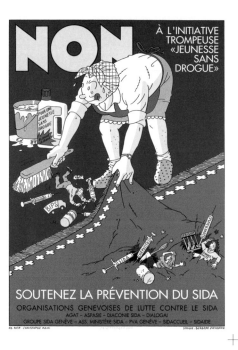

122 **Exem**
Non à la loi sur le travail
1996

124 **Claude Luyet**
Oui à l'édifice social
1992

123 **Elvis Studio graphisme et illustrations /**
Helge Reumann
Non à la fusion des hôpitaux, 1998

125 **Exem**
Non à l'initiative trompeuse «Jeunesse sans drogue»
1997

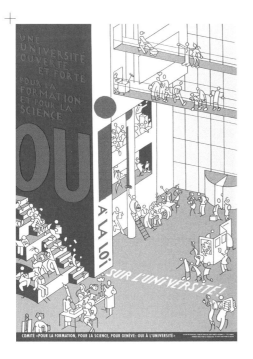

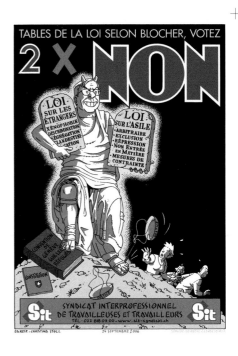

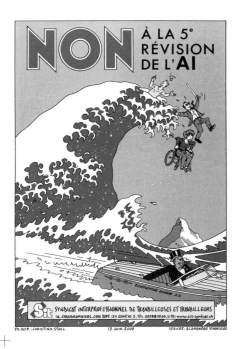

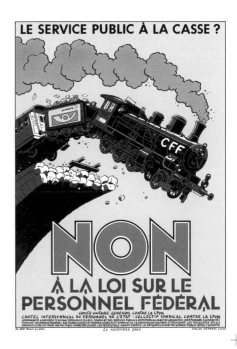

126 **Aloys**
Oui à la loi sur l'université!
2008

127 **Exem**
Non à la 5ᵉ révision de l'AI
2007

128 **Exem**
Tables de la loi selon Blocher, votez 2 × Non
2006

129 **Exem**
Non à la loi sur le personnel fédéral
2000

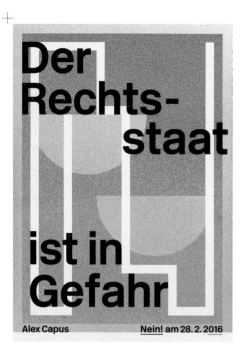

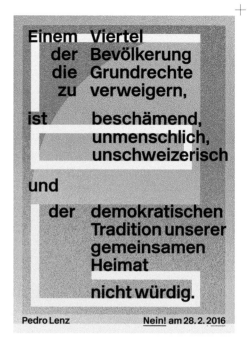

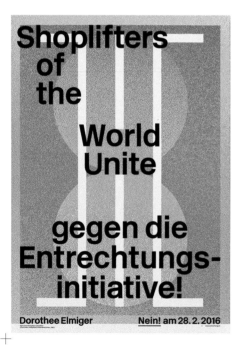

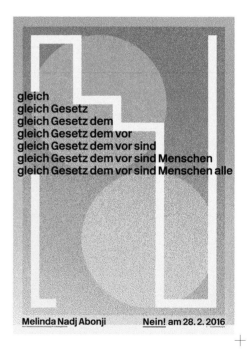

130 **Studio Martin Stoecklin / Martin Stoecklin**
Der Rechtsstaat ist in Gefahr
2016

131 **Studio Martin Stoecklin / Martin Stoecklin**
Shoplifters of the World Unite (…)
2016

132 **Studio Martin Stoecklin / Martin Stoecklin**
Einem Viertel der Bevölkerung die Grundrechte
zu verweigern, (…), 2016

133 **Studio Martin Stoecklin / Martin Stoecklin**
Gleich Gesetz dem vor sind Menschen alle
2016

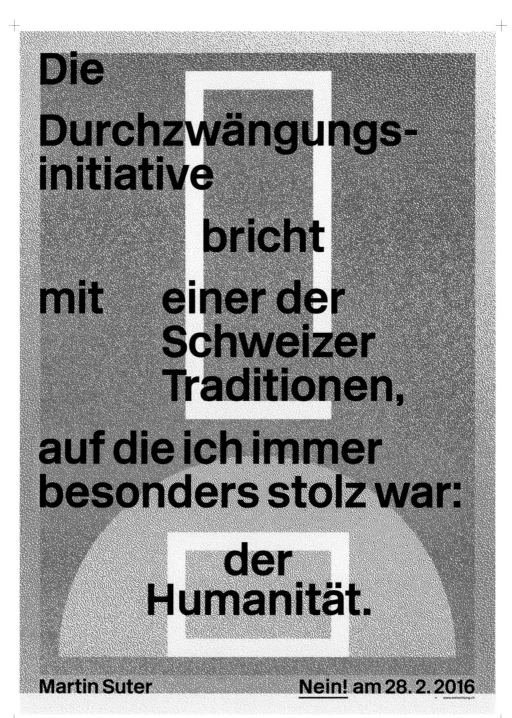

Die Durchzwängungs-initiative bricht mit einer der Schweizer Traditionen, auf die ich immer besonders stolz war: der Humanität.

Martin Suter

Nein! am 28. 2. 2016

→ www.entrechtung.ch

134 **Studio Martin Stoecklin / Martin Stoecklin**
Die Durchzwängungsinitiative bricht mit einer
der Schweizer Traditionen, (…)
2016

135 **Typosalon / Christof Nüssli**
Nein zur Einbürgerungsinitiative
2008

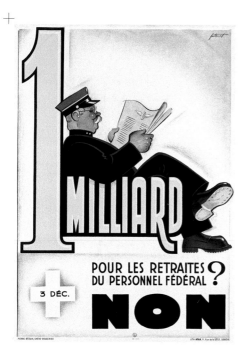

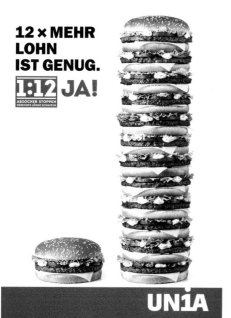

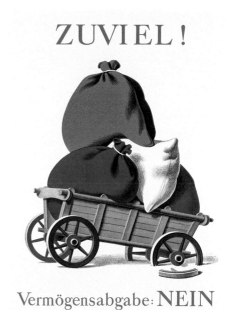

136 **Noël Fontanet**
1 Milliard pour les retraites du personnel fédéral? Non
1939

137 **Anonym**
12 × mehr Lohn ist genug. 1:12 Ja!
2013

138 **Anna Frei**
Nein zum neuen Polizeireglement
2005

139 **Peter Birkhäuser**
Zuviel! / Vermögensabgabe: Nein
1936

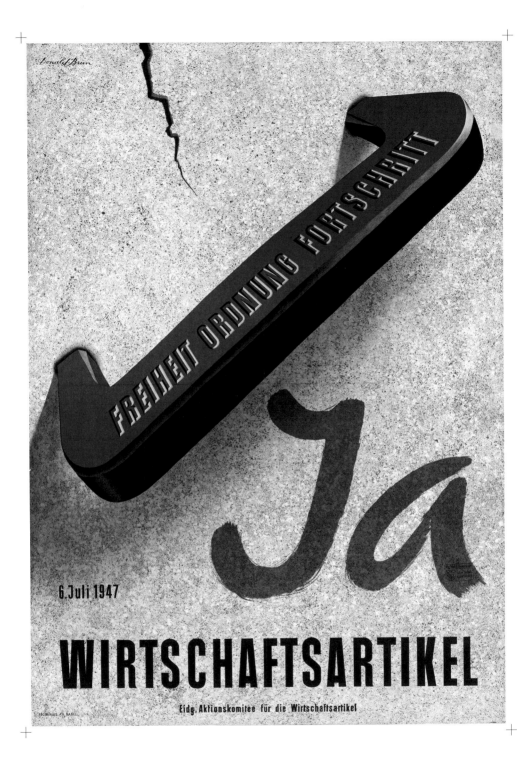

140 **Donald Brun**
Wirtschaftsartikel Ja
1947

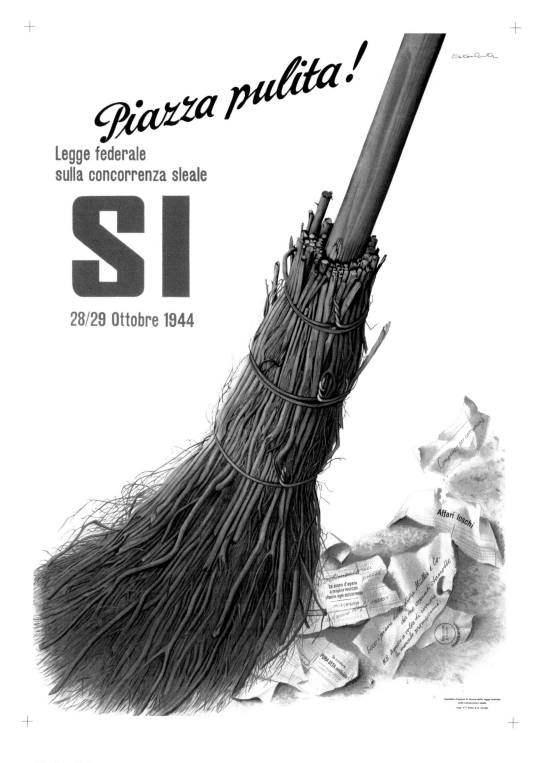

141 **Viktor Rutz**
Legge federale sulla concorrenza sleale Sì
1944

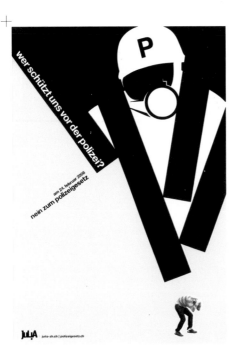

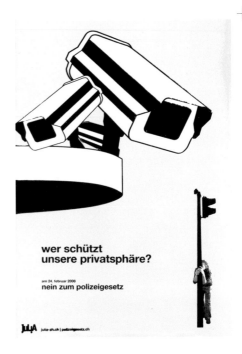

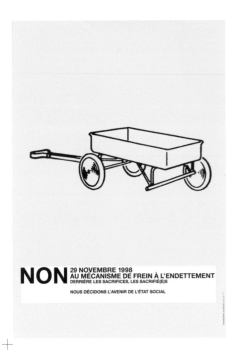

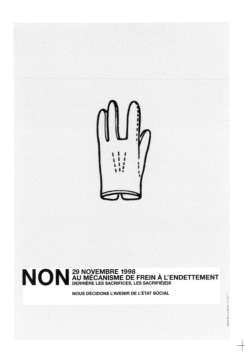

142 **Typosalon / Christof Nüssli**
Nein zum Polizeigesetz
2008

143 **David Rust**
Non au mécanisme de frein à l'endettement
1998

144 **Typosalon / Matthias Gubler**
Nein zum Polizeigesetz
2008

145 **David Rust**
Non au mécanisme de frein à l'endettement
1998

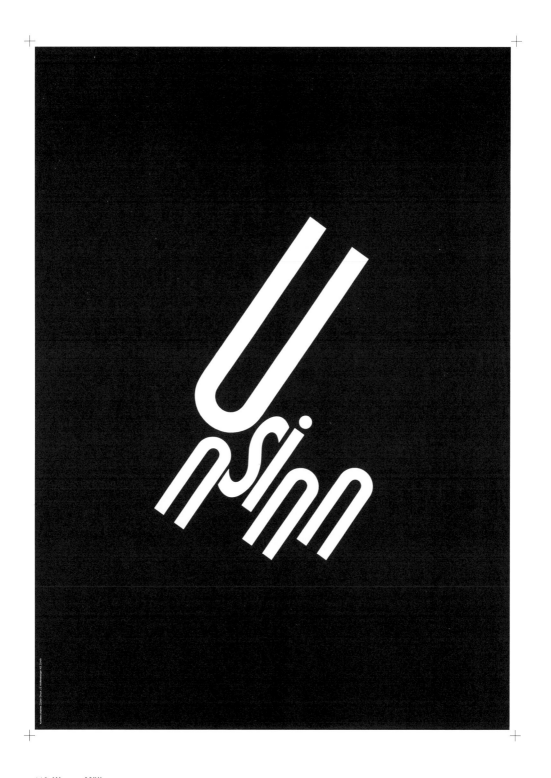

146 **Werner Müller**
Unsinn
1973

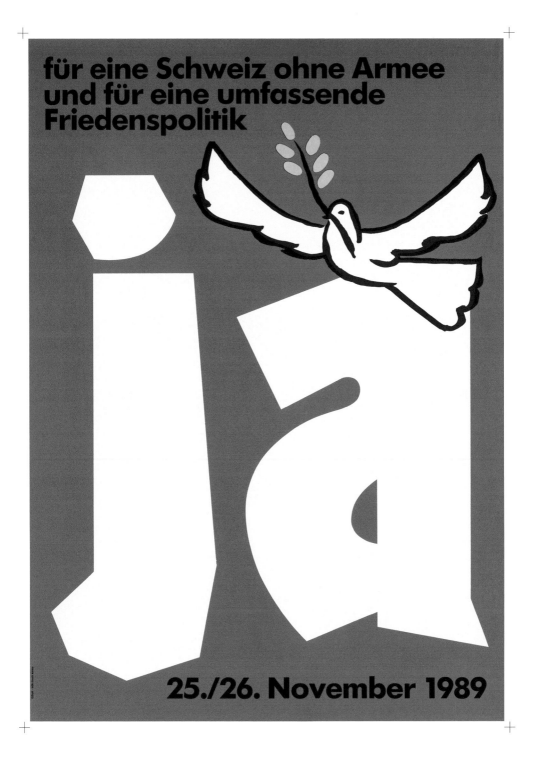

147 **Anonym**
Für eine Schweiz ohne Armee und für
eine umfassende Friedenspolitik Ja
1989

Katalog

Alle abgebildeten Plakate stammen aus der
Plakatsammlung des Museum für Gestaltung Zürich.
Die Rechte (insbesondere Urheberrechte) liegen
bei den Autoren bzw. den Rechteinhabern.
© 2020, ProLitteris, Zurich: Otto Baumberger, Richard
Paul Lohse, Martin Peikert, Niklaus Stoecklin
© Fondation Pierre et Nouky Bataillard: Pierre Bataillard
© Karl Bickel-Stiftung: Karl Bickel

Die Daten des Katalogs folgen den Rubriken Gestaltung,
Plakattext, Erscheinungsjahr, Erscheinungsland,
Drucktechnik, Format und Donationsnachweis. Dabei
gelten insbesondere folgende Regelungen:

Plakattext: Die beste Textwiedergabe bildet die Abbildung
des Plakates selbst. Darum wird hier eine vereinfachte
Form wiedergegeben, welche nur die aussagekräftigen
Textbestandteile berücksichtigt. Allfällige Umstellungen
dienen der Verständlichkeit. Das Zeichen / trennt in-
haltliche Texteinheiten. Jeweils in Klammern nachgestellt
folgt die deutsche und/oder englische Übersetzung.

Erscheinungsland: Das Erscheinungsland wird mit dem
international gebräuchlichen ISO-Code angegeben.

Format: Die Angaben werden in der Abfolge
Höhe × Breite und in Zentimetern gemacht. Weil die
Plakate oft nicht exakt rechtwinklig geschnitten sind,
werden die Abmessungen auf halbe Zentimetern
aufgerundet.

Donationsnachweis: Die Geschichte der Plakatsammlung
geht auf das Jahr 1875 zurück. Angaben zur Herkunft
der Plakate sind in vielen Fällen nicht überliefert. Erst in
jüngerer Zeit werden Donatoren von Plakaten – Insti-
tutionen oder Einzelpersonen – konsequent festgehalten
und in Veröffentlichungen namentlich publiziert.

Die Plakatgeschichte ist ein junges Forschungsgebiet –
verlässliche Hinweise sind rar. Jeder Hinweis und jede
Ergänzung sind willkommen:
sammlungen@museum-gestaltung.ch

Catalogue

All posters reproduced are from the Museum für
Gestaltung Zürich's Poster Collection. The copyrights
are held by the authors or their legal successors.
© 2020, ProLitteris, Zurich: Otto Baumberger, Richard
Paul Lohse, Martin Peikert, Niklaus Stoecklin
© Fondation Pierre et Nouky Bataillard: Pierre Bataillard
© Karl Bickel-Stiftung: Karl Bickel

The data listed in the catalogue is broken down into the
following sections: designer, poster title and/or text,
year and country of first appearance, printing technique,
size, and donor. In particular, the following rules have
been applied:

Poster text: The poster itself provides the best version
of the text, and thus a simplified form is used which
provides only the most meaningful elements. Any
rearrangements that have been made are for purposes
of intelligibility. A slash mark separates textual units
by content. The German and/or English translation is
set in parentheses after the poster text.

Country of first appearance: The country of first
appearance is identified by the internationally accepted
ISO code.

Format: The dimensions are given in centimeters as
height × width. Because posters are often not cut exactly
at right angles, the dimensions are rounded off to the
half-centimeter.

Donor: The history of the Poster Collection goes back
to 1875. In many cases, we lack specific information
concerning the sources of posters in the collection.
Only recently have institutional or individual contributors
of posters been recorded consistently and specified in
our publications.

The history of posters is a recent field of research–
reliable information is rare. Any additional material or
further references are welcome:
sammlungen@museum-gestaltung.ch

1 Donald Brun (1909–1999)
Frauenstimmrecht Nein (Women's
Suffrage No)
1946 CH Lithografie – Lithograph
127 × 90 cm

2 Charles Affolter (1922–?)
Semaine des 44 heures Oui (44-Stunden-
Woche Ja – 44-Hour Workweek Yes)
1958 CH Offset 127 × 90 cm

3 Hubertus Design /
Jonas Voegeli (*1979)
No alla disumana iniziativa dell'UDC
(Nein zur unmenschlichen SVP-Initiative
– No to the SVP's Inhumane Initiative)
2016 CH Digitaldruck – Digital print
128 × 90,5 cm
Donation Jonas Voegeli

4 Bernard Schlup (*1948)
Per vederci chiaro / Sì all'iniziativa
sulle banche (Um klar zu sehen / Ja zur
Bankeninitiative – To See Clearly /
Yes to the Banking Initiative)
1984 CH Offset 127 × 90 cm

5 Josef Müller-Brockmann (1914–1996)
Projet constitutionnel sur le routier
réseau Oui (Verfassungsprojekt zum
Strassennetz Ja – Constitutional Road
Network Project Yes)
1958 CH Offset 127 × 90 cm

6 Noël Fontanet (1898–1982)
Gegen die Macht der Geheimgesell-
schaften / Freimaurerverbot Ja
(Against the Power of Secret Societies /
Ban on Freemasons Yes)
1937 CH Lithografie – Lithograph
127 × 90 cm

7 Exem (*1951)
Non au seuil d'intolérance / Le 24 sep-
tembre 2000 votez Non à l'initiative
xénophobe des «18 %» (Nein zu Intole-
ranz / Stimmt am 24. September 2000
Nein zur fremdenfeindlichen Initiative
der «18 %» – No to the Intolerance
Threshold / On September 24, 2000,
Vote No on the Xenophobic "18 %"
Initiative)
2000 CH Siebdruck – Screen print
128 × 90,5 cm
Donation Allgemeine Plakatgesellschaft,
APG, Zürich

8 Automatico / Demian Conrad (*1974)
Sì (Ja – Yes)
[Initiative für ein bedingungsloses
Grundeinkommen – Initiative for an
Unconditional Basic Income]
2016 CH Siebdruck – Screen print
128 × 90,5 cm
Donation Verein First World Develop-
ment, Volksinitiative für ein bedingungs-
loses Grundeinkommen, Basel

9 Melchior Annen (1868–1954)
Gerechtigkeit erhöht ein Volk! Majorz /
Proporz / Eidgenossen, am 13. Okt.
stimmt: Ja! (Justice Elevates a People!
Majority Rule / Proportional Represen-
tation / Confederates, on Oct. 13,
Vote: Yes!)
1918 CH Lithografie – Lithograph
57 × 79,5 cm

10 Otto Jakob Plattner (1886–1951)
Wohnungsbau-Initiative Nein! (Housing
Construction Initiative No)
1926 CH Lithografie – Lithograph
127 × 90 cm

11 Ferdinand Schott (1887–1964)
Strömt herbei Ihr Völkerscharen!
Extrazulage an Arbeitslose Nein
(Come in Flocks, You Multitudes!
Extra Unemployment Benefit No)
1926 CH Lithografie – Lithograph
127 × 90 cm

12 Emil Cardinaux (1877–1936)
Gegen Strassengewalt / Für demokrati-
sche Ordnung / Gesetz zum Schutze
der öffentl. Ordnung Ja (Against Street
Violence / For Democratic Order /
Law to Safeguard Public Order Yes)
1934 CH Lithografie – Lithograph
128 × 90,5 cm

13 Niklaus Stoecklin (1896–1982)
Die Reichen fliehen / Die Armen zahlen.
(The Rich Flee / The Poor Pay.)
1921 CH Lithografie – Lithograph
127 × 90 cm

14 Niklaus Stoecklin (1896–1982)
Vermögensabgabe / Staatswirtschaft
(Capital Levy / State-Run Economy)
1922 CH Lithografie – Lithograph
127 × 90 cm

15 Hans Falk (1918–2002)
Stadion Ja (Stadium Yes)
1953 CH Lithografie – Lithograph
127 × 90 cm

16 Hans Falk (1918–2002)
Per la famiglia Sì il 25 nov. 1945
(Für die Familie Ja am 25. Nov. 1945 –
For the Family Yes on Nov. 25, 1945)
1945 CH Lithografie – Lithograph
127 × 90 cm

17 Hans Erni (1909–2015)
Oui (Ja – Yes)
1947 CH Lithografie – Lithograph
127 × 90 cm

18 Dora Hauth-Trachsler (1874–1957)
Nein der Arbeitszeit-Verlängerung
(No to Longer Working Hours)
1924 CH Lithografie – Lithograph
127 × 90 cm

19 Hugo Laubi (1888–1959)
Erbschafts- u. Schenkungssteuer
Nein (Inheritance and Gift Tax No)
1936 CH Lithografie – Lithograph
127 × 90 cm

20 Viktor Rutz (1913–2008)
Kantonale Altersversicherung Ja
(Cantonal Old-Age Insurance Yes)
1941 CH Lithografie – Lithograph
127 × 90 cm

21 Heiner Bauer (1922–1981)
44 Stunden Woche Ja (44-Hour
Week Yes)
1958 CH Offset 127 × 90 cm

22 József Divéky (1887–1951)
Wer die Alters- u. Invalidenversiche-
rung will, stimmt für die Vermögens-
abgabe Ja! (If You Want Old-Age
and Disability Insurance, Vote Yes
for the Capital Levy!)
1922 CH Lithografie – Lithograph
130 × 90,5 cm

23 Florentin Moll (1884–1942)
Arbeitszeitverlängerung Nein
(Longer Working Hours No)
1924 CH Lithografie – Lithograph
127 × 90 cm

24 Alfred Heinrich Pellegrini (1881–
1958)
Schon wieder Nacht / Stimmet Nein
(Night Again / Vote No)
1924 CH Lithografie – Lithograph
127 × 90 cm

25 Karl Bickel (1886–1982)
Ja / Alter / Invalidität (Yes / Old Age /
Disability)
1925 CH Lithografie – Lithograph
127 × 90 cm

26 Kaspar Gisler Reklameberatung /
Hannes Portmann (1927–2007)
Zwangsstaat? Bevogtung?
Preisdiktatur Nein (Coercive State?
Paternalism? State-Controlled
Prices No)
1952 CH Offset 127 × 90 cm

27 Donald Brun (1909–1999)
Sand ins Getriebe / Vermögens-
abgabe Nein (Gumming Things Up /
Capital Levy No)
1952 CH Lithografie – Lithograph
127 × 90 cm

28 Otto Baumberger (1889–1961)
Chiropraktik Nein (Chiropractic
Treatment No)
1939 CH Lithografie – Lithograph
127 × 90 cm
Donation Schweiz Tourismus, Zürich

29 Goal AG für Werbung und Public Relations
Stop / Ja zur Einbürgerungsinitiative (Stop / Yes on the Naturalization Initiative)
2008 CH Offset 169,5 × 116 cm
Donation Allgemeine Plakatgesellschaft, APG, Zürich

30 Hans Beat Wieland (1867–1945)
Herunter mit dem Brotkorb! Eidg. Volksabst. 5. Dez. / Brotmonopol Nein! (Lower the Bread Basket! Confederate Referendum Dec. 5 / Bread Monopoly No!)
1926 CH Lithografie – Lithograph 128 × 90,5 cm

31 Carl Scherer (1890–1953)
Schützt Freiheit und Ordnung! Ordnungsgesetz Ja (Protect Liberty and Public Order! Law to Safeguard Public Order Yes)
1934 CH Lithografie – Lithograph 127 × 90 cm

32 Hans Beat Wieland (1867–1945)
Umsturzgesetz: Ja! (Sedition Act: Yes!)
1922 CH Lithografie – Lithograph 127 × 90 cm

33 René Gilsi (1905–2002)
Stop al rincaro / Iniziativa popolare Sì (Inflation stoppen / Volksinitiative Ja – Stop Inflation / Popular Initiative Yes)
1955 CH Lithografie – Lithograph 128 × 90,5 cm

34 Alois Carigiet (1902–1985)
Lohnabbau Nein (Wage Cuts No)
1933 CH Lithografie – Lithograph 128 × 90,5 cm

35 Otto Baumberger (1889–1961)
Hütet Euch vor dem Versailler Völkerbund (Beware of the Versailles League of Nations)
1920 CH Lithografie – Lithograph 127 × 90 cm

36 Carl Scherer (1890–1953)
Wahrt Eure Freiheit! Lex Häberlin Nein (Maintain Your Liberty! Lex Häberlin No)
1922 CH Lithografie – Lithograph 127 × 90 cm

37 Hugo Schuhmacher (1939–2002)
Gegen den Atomvogt / Atomschutz Ja (Against Nuclear Paternalism / Nuclear Safety Yes)
1979 CH Siebdruck – Screen print 127 × 90 cm

38 Kilian Moser (*1969)
Neues Wahlgesetz / Nein zum Verbot von Listenverbindungen / Rettet die Demokratie! (New Election Law / No to Prohibiting Combined Lists / Save Democracy!)

2010 CH Digitaldruck – Digital print 128 × 90,5 cm
Donation Kilian Moser

39 Atelier Bataillard / Pierre Bataillard (1927–2008)
Affaiblir le pays? Non (Das Land schwächen? Nein – Weaken the Country? No)
1972 CH Offset 128 × 90,5 cm

40 Hugo Laubi (1888–1959)
L'initiativa da la front Na (Fronteninitiative Nein – Front Initiative No)
1935 CH Lithografie – Lithograph 127 × 90 cm

41 Charles L'Eplattenier (1874–1946)
Initiative de crise Non (Kriseninitiative Nein – crisis Initiative No)
1935 CH Lithografie – Lithograph 128 × 90,5 cm

42 KSP Krieg Schlupp Partner
Weniger Waffen. Weniger Waffengewalt. Ja zum Waffengesetz (Fewer Guns. Less Gun Violence. Yes to the Gun Law)
2019 CH Offset 128 × 90,5 cm
Donation Allgemeine Plakatgesellschaft, APG, Zürich

43 Anonym
Oui aux Casques bleus / La Suisse doit participer! (Ja zu den Blauhelmen / Die Schweiz muss sich beteiligen! – Yes to the Blue Helmets / Switzerland Must Participate!)
1994 CH Offset 128 × 90,5 cm
Donation Allgemeine Plakatgesellschaft, APG, Zürich

44 Theo Ballmer (1902–1965)
Militärmoloch, Krieg / Faschismus / Militärvorlage Nein! (Military Behemoth, War / Fascism / Military Proposal No!)
1935 CH Hochdruck – Letterpress printing 128 × 90,5 cm

45 Theo Ballmer (1902–1965)
Arbeiter, Angestellte, Kleingewerbetreibende! Am 10. und 11. März verwerft im Massenaufmarsch das faschistische Zuchthausgesetz / Schliesst die Einheitsfront gegen Faschismus und Krieg! Nieder mit der neuen Lex Häberlin! Herunter mit dem Gesslerhut! Stimmt Nein! (Workers, Employees, Tradesmen! Reject the Fascist Prison Law in a Rally on March 10 and 11 / Join the United Front Against Fascism and War! Down with the New Lex Häberlin! Down with the Gessler Hat! Vote No!)
1934 CH Hochdruck – Letterpress printing 128 × 90,5 cm

46 Anonym
«Hauptsache der Samstagsjass überlebt.» Atom macht keinen Stich. 3 × Ja ("As Long As Our Weekly Card Game Survives." Nuclear Energy Isn't a Trump Card. 3 × Yes)
1990 CH Offset 128 × 90,5 cm

47 Atelier Rolf Bangerter / Rolf Bangerter (1922–1994)
Flughafen Kloten / Der weltoffene Zürcher sagt Ja (Kloten Airport / The Cosmopolitan People of Zurich Say Yes)
1946 CH Lithografie – Lithograph 128 × 90,5 cm

48 Noël Fontanet (1898–1982)
Die Welt ist in Brand / Erschwere nicht noch mehr die Aufgabe der Landesbehörden / Stimme Nein am 25. Januar (The World Is on Fire / Don't Make the Task of the State Authorities Even More Difficult / Vote No on January 25)
1942 CH Lithografie – Lithograph 127 × 90 cm

49 Anonym
Nein am 27.9. zur überholten VKMB-Denner-Initiative, weil sie unsere Landschaft aufs Spiel setzt. (No on Sep. 27 to the Outmoded Initiative of the Farmers' Association and Denner, Because It Endangers Our Countryside.)
1998 CH Offset 128 × 90,5 cm
Donation Allgemeine Plakatgesellschaft, APG, Zürich

50 Anonym
Unsere Armee abschaffen: Nein. (Abolish Our Army: No.)
1989 CH Offset 128 × 90,5 cm

51 Hans Erni (1909–2015)
Gesellschaft Schweiz-Sowjetunion / Wir erstreben freundschaftliche und vertrauensvolle Beziehungen zwischen unserem Lande und der Sowjetunion (Switzerland–Soviet Union Society / We Strive for Friendly and Trusting Relations Between Our Country and the Soviet Union)
1945 CH Lithografie – Lithograph 127 × 90 cm
Donation Kloster Einsiedeln

52 Werbeagentur Edgar Küng
Wenn die Pyramide fällt, fällt auch Du! Überfremdungsinitiative 3 Nein (If the Pyramid Collapses, So Will You! Inundation by Foreigners Initiative 3 No)
1974 CH Offset 128 × 90,5 cm

53 Jean Leffel (1918–2001)
Prospérité / Schwarzenbach / Votez Non (Wohlstand / Schwarzenbach / Stimmt Nein – Prosperity / Schwarzenbach / Vote No)
1970 CH Offset 128 × 90,5 cm

54 Linard Biert
Zur Initiative gegen die Überfremdung
ein klares Nein (To the Initiative
Against Inundation by Foreigners
an Emphatic No)
1970 CH Offset 128 × 90,5 cm

55 Goal AG für Werbung und Public
Relations / Hans-Rudolf Abächerli
(*1928)
Stop dem Asyl-Missbrauch (Stop the
Abuse of Asylum)
1999 CH Offset 128 × 90,5 cm
Donation Schweizerische Volkspartei
des Kantons Zürich, SVP, Dübendorf

56 Exem (*1951)
Non aux mesures de contrainte
(Nein zu Zwangsmassnahmen –
No to Compulsory Measures)
1994 CH Siebdruck – Screen print
128 × 90,5 cm

57 Eric Andersen (*1981)
Die Angst vor der Angstmacherei /
Wovor hast du Angst? Welche Proble-
me haben wir? Gibt es ein Schweizer
Volk? (…) 2 × Nein gegen ausländer-
feindliche Politik (Fear of Fearmonge-
ring / What Are You Afraid Of? What
Problems Do We Have? Is There
a Swiss People? (…) 2 × No Against
Xenophobic Policies)
2010 CH Offset 100 × 70 cm
Donation Eric Andersen

58 Otto Jakob Plattner (1886–1951)
Extragabe an Ausländer 2 mal Nein
(Extra Allowance for Foreigners
2 Times No)
1933 CH Lithografie – Lithograph
127 × 90 cm

59 Goal AG für Werbung und Public
Relations
Sicherheit verlieren? Arbeit verlieren?
Schengen Nein (Lose Security?
Lose Your Job? Schengen No)
2005 CH Offset 128 × 90,5 cm
Donation Schweizerisches Aktions-
komitee gegen den Schengen-/
EU-Beitritt

60 Goal AG für Werbung und Public
Relations
Stopp / Ja zum Minarettverbot
(Stop / Yes to a Ban on Minarets)
2009 CH Siebdruck – Screen print
128 × 90,5 cm
Donation Initiativkomitee «Gegen
den Bau von Minaretten», Flaach

61 Typosalon / Christof Nüssli (*1986)
Stopp / Ja zum Verbot von Kriegs-
material-Exporten (Stop / Yes to a Ban
on Exports of War Matériel)
2009 CH Offset 128 × 90,5 cm
Donation Christof Nüssli

62 Euro RSCG / Frank Bodin (*1962)
Le ciel suisse est suffisamment vaste
pour abriter toutes les croyances.
Non à l'intolérance. Non à l'initiative
antiminarets. (Der Schweizer Himmel
ist weit genug, um alle Glaubens-
richtungen zu schützen. Nein zu Intol-
eranz. Nein zur Antiminarett-Initiative –
The Swiss Skies Are Vast Enough to
Accommodate All Faiths. No to Intoler-
ance. No to the Anti-Minaret Initiative.)
2009 CH Digitaldruck – Digital print
42 × 59,5 cm
Donation Havas Worldwide, Zürich/
Genf

63 Fredy Prack (*1940),
René Beuret (*1936)
Wir alle leben mit Strom / Beteiligung
Kernkraftwerk Gösgen Ja (All of Us
Live with Electricity / Public Share in
the Gösgen Nuclear Power Plant Yes)
1974 CH Offset 128 × 90,5 cm

64 Anonym
Salviamo le nostre acque! 2 Sì
(Retten wir unsere Gewässer! 2 Ja –
Save Our Waterways! 2 Yes)
1992 CH Offset 128 × 90,5 cm

65 Otto Baumberger (1889–1961)
Wollt Ihr solche Frauen? / Frauen-
stimmrecht Nein (Do You Want Women
Like This? / No to Women's Suffrage)
1920 CH Lithografie – Lithograph
127 × 90 cm

66 Atelier Eidenbenz / Hermann
Eidenbenz (1902–1993)
Ein freies Volk braucht freie Frauen /
Frauenstimmrecht Ja (A Free People
Needs Free Women / Yes to Women's
Suffrage)
1946 CH Hochdruck – Letterpress
printing 128 × 90,5 cm

67 Niklaus Stoecklin (1896–1982)
Kein Frauenstimmrecht (No Women's
Suffrage)
1920 CH Lithografie – Lithograph
127 × 90 cm

68 Hugo Laubi (1888–1959)
Frauenstimmrecht Nein! Mamme wenn
kunsch haim? (Frauenstimmrecht Nein!
Mutter, wann kommst Du nach Hause?
– Women's Suffrage No! Mother, When
Are You Coming Home?)
1946 CH Lithografie – Lithograph
127 × 90 cm

69 Dora Hauth-Trachsler (1874–1957)
Zum Schutz der Jugend u. der
Schwachen / Frauenwahlrecht «Ja»
(To Protect the Youth and the Vulner-
able / Women's Suffrage "Yes")
1920 CH Lithografie – Lithograph
116 × 80 cm

70 Beatrice Afflerbach (1920–2003)
My Mammi goht go stimme (Meine
Mami geht stimmen – My Mommy Is
Going Out to Vote)
1954 CH Lithografie – Lithograph
128 × 90,5 cm

71 Jürg Spahr (1925–2002)
Frauenstimmrecht Ja (Women's
Suffrage Yes)
1959 CH Lithografie – Lithograph
127 × 90 cm

72 Anonym
Frauenstimmrecht Nein (Women's
Suffrage No)
1959 CH Lithografie – Lithograph
127 × 90 cm

73 Wilhelm Wenk (1890–1956)
Der Frauenstimmrechtsgegner: Der
Staat bin ich! Was geht das die Frauen
an? Wer kein Spiessbürger ist,
stimmt Ja (The Opponent of Women's
Suffrage: I Am the State! How Does
That Concern Women? If You're Not
Narrow-Minded, Vote Yes)
1946 CH Lithografie – Lithograph
127 × 90 cm

74 Anonym
Den Frauen zuliebe – ein männliches
Ja (For Women's Sake – A Manly Yes)
1971 CH Offset 128 × 90,5 cm

75 Margrit Gams
Verantwortung / Frauenstimmrecht
(Responsibility / Women's Suffrage)
1920 CH Lithografie – Lithograph
128 × 90,5 cm

76 Dora Hauth-Trachsler (1874–1957)
Frauenstimmrecht (Women's Suffrage)
1920 CH Lithografie – Lithograph
127 × 90 cm

77 Richard Paul Lohse (1902–1988)
Photo: Jakob Tuggener (1904–1988)
Zämme schaffe – zämme stimme /
Ja (Zusammen arbeiten – zusammen
stimmen / Ja – Work Together –
Vote Together – Yes)
1947 CH Tiefdruck – Gravure print
127 × 90 cm

78 Hans Erni (1909–2015)
Gleiche Pflicht / Gleiches Recht /
Frauenstimmrecht Ja (Equal Duties /
Equal Rights / Women's Suffrage Yes)
1946 CH Lithografie – Lithograph
127 × 90 cm

79 Anonym
Manne, s'isch Zyt für es grosszügigs
Ja / Stimmrecht für Mann und Frau
Ja (Männer, es ist Zeit für ein gross-
zügiges Ja / Stimmrecht für Mann und
Frau Ja – Men, It Is Time for a

Generous Yes / Voting Rights for Men
and Women Yes)
1966 CH Offset 128 × 90,5 cm

80 Anonym
Frauen ins Laufgitter? Frauen
in die Politik? Beides schadet guter
Frauenart! Darum politisches Frauen-
stimmrecht Nein (Women in the
Playpen? Women in Politics? Both
Are Unladylike! Hence Women's
Political Suffrage No)
1959 CH Hochdruck – Letterpress
printing 127 × 90 cm

81 Charles Affolter (1922–?)
Le vote des femmes vivifiera la démo-
cratie / Oui (Das Frauenstimmrecht
belebt die Demokratie / Ja –
The Women's Vote Will Invigorate
Democracy / Yes)
1960 CH Hochdruck – Letterpress
printing 127 × 90 cm

82 Anonym
Zusammenarbeit für Familie und Staat
Ja / Für das Frauenstimmrecht Ja
(Teaming up for Family and Country
Yes / For Women's Suffrage Yes)
1959 CH Offset 127 × 90 cm

83 Anonym
Frauenstimmrecht Nein (Women's
Suffrage No)
1946 CH Lithografie – Lithograph
128 × 90,5 cm

84 Exem (*1951)
Non / Pas de cadeau à la Société
des Hôtels Président S.A. / Wilson aux
habitants de Genève (Nein / Keine
Geschenke an die Président Hotel-
gesellschaft / [Palais] Wilson der Gen-
fer Bevölkerung – No / No Gifts to the
Président Hotel Company / [Palais]
Wilson for the People of Geneva)
1990 CH Siebdruck – Screen print
128 × 90,5 cm

85 Exem (*1951)
Non à la destruction des Bains des
Pâquis (Nein zur Zerstörung der
Bains des Pâquis – No to Destroying
the Bains des Pâquis)
1988 CH Siebdruck – Screen print
128 × 90,5 cm

86 Exem (*1951)
Non à un projet «Titanic» / 2 × Non à
cette traversée (Nein zu einem
Projekt «Titanic» / 2 × Nein zu dieser
Kreuzung – No to a "Titanic" Project /
2 × No to This Crossing)
1996 CH Siebdruck – Screen print
128 × 90,5 cm

87 Carl Moos (1878–1959)
Uccidiamo questo mostro dei paragrafi!
Nuova legge sulla concorrenza sleale
No (Töten wir dieses Paragrafen-
monster! Neues Gesetz zum unlauteren
Wettbewerb Nein – Let's Slay This
Regulations Monster! New Law on
Unethical Competition No)
1944 CH Lithografie – Lithograph
126 × 90 cm

88 Niklaus Stoecklin (1896–1982)
Soll Basel 30 Jahre zurückkrebsen?
Museumsbau Ja (Crabby for Another
30 Years? Museum Construction Yes)
1932 CH Lithografie – Lithograph
127 × 90 cm

89 Karl Schlegel (1892–1960)
Es wandert von Kanton zu Kanton /
Gesetz über die Patentpflicht von
Gewerben / Nein, auch wir «fressen»
das nicht (It Roams from Canton to
Canton / Law Mandating Commercial
Licenses / No, We're Not "Swallowing"
It Either)
1936 CH Lithografie – Lithograph
130 × 92,5 cm

90 Martin Peikert (1901–1975)
Ein Ja der Wildpflege (Yes to Wildlife
Conservation)
1954 CH Lithografie – Lithograph
100,5 × 61,5 cm
Donation Suzanne Marie Peikert-
Borboën

91 Hans Beat Wieland (1867–1945)
Für Ordnung und Vaterland /
Militärjustiz-Initiative: Nein (For Order
and Fatherland / Military Justice
Initiative: No)
1921 CH Lithografie – Lithograph
127 × 90 cm

92 Reumann Atelier Carton /
Helge Reumann (*1966)
Un petit effort pour demain / Oui le
21 juin (Ein kleiner Aufwand für morgen
/ Ja am 21. Juni – A Small Effort
for Tomorrow / Yes on June 21)
1987 CH Siebdruck – Screen print
128 × 90,5 cm

93 Goal AG für Werbung und Public
Relations
Ausschaffungsinitiative Ja / Gegenent-
wurf Nein (Expulsion Initiative Yes /
Counterproposal No)
2010 CH Offset 128 × 271 cm

94 Goal AG für Werbung und Public
Relations
Freipass für alle? Nein (Free Pass
for All? No)
2009 CH Offset 127 × 271 cm
Donation Allgemeine Plakatgesellschaft,
APG, Zürich

95 Stephan Bundi (*1950)
Ja zur Bankeninitiative (Yes to the
Bank Initiative)
1984 CH Siebdruck – Screen print
60 × 42 cm

96 Elvis Studio graphisme et illustra-
tions / Helge Reumann (*1966)
Bénéfices immobiliers: Oui à la justice
fiscale (Immobiliengewinne: Ja
zu gerechten Steuern – Real Estate
Profits: Yes to Fair Taxation)
1998 CH Siebdruck – Screen print
127 × 90 cm

97 Stephan Bundi (*1950)
Gegen das Geschäft mit dem Tod. Für
ein Waffenausfuhrverbot. (Against the
Death Trade. For a Ban on Arms
Exports.)
1972 CH Offset 61 × 42 cm

98 Les Studios Lolos / Aloys (*1953)
Non à la mainmise des patrons / Non
au projet de loi contre la fonction pub-
lique (Nein zum Würgegriff der Chefs /
Nein zum Gesetzesentwurf gegen den
öffentlichen Dienst – No to the Bosses'
Stranglehold / No to the Bill Opposing
Civil Service)
1989 CH Siebdruck – Screen print
128 × 90,5 cm

99 Niklaus Stoecklin (1896–1982)
Das Volk lässt sich nicht prellen!
Überprüfung des Staatshaushaltes
Ja (The People Will Not Be Cheated!
Audit the National Budget Yes)
1939 CH Lithografie – Lithograph
127 × 90 cm

100 Emil Cardinaux (1877–1936)
Vermögensabgabe Nein (Capital
Levy No)
1922 CH Lithografie – Lithograph
127 × 90 cm

101 Atelier Häusler
31. Oktober 1920 Nein (October 31,
1920 No)
1920 CH Lithografie – Lithograph
123 × 86 cm

102 Anonym
Pas de bailli fédéral sur votre sol
et vos habitations / Votez Non (Kein
Bundesvogt auf Eurem Grund und
Boden / Stimmt Nein – Don't Let the
Government Trespass on Your
Property / Vote No)
1950 CH Lithografie – Lithograph
127 × 90 cm

103 Hugo Laubi (1888–1959)
Direkte Bundessteuer Ja! (Direct
Federal Taxation Yes!)
1918 CH Lithografie – Lithograph
128 × 90,5 cm

104 Charles Edouard Gogler
(1885–1976)
Confiscation de la propriété Non
(Konfiszierung des Eigentums Nein –
Confiscation of Property No)
1922 CH Lithografie – Lithograph
127 × 90 cm

105 Raymond Naef (*1948)
Wachstum über alles? HB-Südwest
Nein (Growth Before Everything Else?
HB-Südwest Project No)
1988 CH Siebdruck – Screen print
128 × 90,5 cm

106 Bernard Schlup (*1948)
Atomschutzinitiative für unsere Zukunft
Ja (Nuclear Safety Initiative for Our
Future Yes)
1981 CH Offset 42 × 29,5 cm

107 Born / Lutz / Münger
Kaiseraugst: Nein (Kaiseraugst: No)
1979 CH Offset 128 × 90,5 cm

108 Jürg Stauffer (*1950)
Atomschutz Ja (Nuclear Safety Yes)
1979 CH Offset 60 × 42 cm

109 Bernard Schlup (*1948)
«Wehret den Anfängen!» Atomschutz
Ja (“Get It Right from the Beginning!”
Nuclear Safety Yes)
1979 CH Offset 60 × 42 cm

110 Heiri Strub (1916–2014)
Fristenlösung Ja (Limiting the
Time Frame of Abortions Yes)
1977 CH Siebdruck – Screen print
127 × 90 cm

111 Ernst Keller (1891–1968)
Verpfuschter Zahn / Verpfuschte
Gesundheit / Zahntechniker-Initiative
Nein (Botched Tooth / Botched Health
/ Dental Technicians’ Initiative No)
1946 CH Hochdruck – Letterpress
printing 127 × 90 cm
Donation Annemarie Kuhl-Brauchli

112 Aldo Patocchi (1907–1986)
Nein / 90 Tage Rekrutenschule? Ver-
mehrter Drill als Rettung vor der
Kriegshölle? (No / 90 Days of Basic
Training? Are More Drills Supposed
to Avert the Horrors of War?)
1935 CH Lithografie – Lithograph
128 × 90,5 cm

113 Anonym
Nur das Beste.. Ja ..aber billiger und
für alle / Verbilligung der künstlichen
Gebisse (Only the Best.. Yes ..But
Cheaper and for Everyone / Lower
Prices for Dentures)
1960 CH Hochdruck – Letterpress
printing 127 × 90 cm

114 Simon (*1953)
Réfuser l’armée c’est préparer la paix /
Oui à l’initiative pour une Suisse sans
armée (Militärverweigerung bedeutet,
den Frieden vorzubereiten / Ja zu einer
Initiative für eine Schweiz ohne Armee
– To Refuse to Enlist Is to Lay the
Groundwork for Peace / Yes to the Ini-
tiative for a Switzerland without an
Army)
1989 CH Siebdruck – Screen print
128 × 90,5 cm

115 Fred Stauffer (1892–1980)
Fabrikgesetz Art. 41 Ja / Erobert den
Platz an der Sonne zurück! (Factory
Law Art. 41 Yes / Reclaim Your Place in
the Sun!)
1924 CH Lithografie – Lithograph
127 × 90 cm

116 Emil Cardinaux (1877–1936)
Ja dem Völkerbund (Yes to the League
of Nations)
1920 CH Lithografie – Lithograph
64 × 45 cm

117 Otto Baumberger (1889–1961)
1 Milliarde für die Pensionen des Bun-
despersonals am 3. Dezember? Nein!
(1 Billion for the Pensions of Federal
Employees on December 3? No!)
1939 CH Lithografie – Lithograph
128 × 90,5 cm

118 Hugo Laubi (1888–1959)
Tuberkulose-Gesetz Nein (Tuberculosis
Control Act No)
1949 CH Lithografie – Lithograph
128 × 90,5 cm

119 Jules-Ami Courvoisier (1884–1936)
Durch Arbeit zum Wohlstand / Lasst
mich arbeiten, stimmt: Ja! (Achieve
Prosperity through Labor / Let Me
Work, Vote: Yes!)
1924 CH Lithografie – Lithograph
127 × 90 cm

120 Anonym
Nein zur «Selbstbestimmungsinitiative»
(No to the “Self-Determination Initia-
tive”)
2018 CH Digitaldruck – Digital print
121,5 × 85,5 cm
Donation Operation Libero, Bern

121 Hans Erni (1909–2015)
Sì (Ja – Yes)
1949 CH Lithografie – Lithograph
128 × 90,5 cm

122 Exem (*1951)
Non à la loi sur le travail (Nein zum
Arbeitsgesetz – No to the Labor Law)
1996 CH Siebdruck – Screen print
128 × 90,5 cm

123 Elvis Studio graphisme et
illustrations / Helge Reumann (*1966)
Non à la fusion des hôpitaux (Nein
zum Spitalzusammenschluss – No to
the Hospital Merger)
1998 CH Siebdruck – Screen print
128 × 90,5 cm

124 Claude Luyet (*1948)
Oui à l’édifice social / Contre l’égoïsme:
la solidarité (Ja zum Sozialstaat /
Gegen den Egoismus: Solidarität – Yes
to Society / Against Selfishness: Soli-
darity)
1992 CH Siebdruck – Screen print
128 × 90,5 cm

125 Exem (*1951)
Non à l’initiative trompeuse «Jeunesse
sans drogue» / Soutenez la prévention
du sida (Nein zur irreführenden
Initiative «Jugend ohne Drogen» /
Unterstützt die Aids-Prävention – No
to the Misleading “Drug-Free Youth”
Initiative / Support AIDS Prevention)
1997 CH Siebdruck – Screen print
128 × 90,5 cm

126 Aloys (*1953)
Oui à la loi sur l’université! Une univer-
sité ouverte et forte pour la formation
et pour la science (Ja zum Universitäts-
gesetz! Eine offene und starke Univer-
sität für Bildung und Wissenschaft –
Yes to the University Act! An Open and
Strong University for Education and
Research)
2008 CH Siebdruck – Screen print
128 × 90,5 cm

127 Exem (*1951)
Non à la 5e révision de l’AI [assurance
invalidité] (Nein zur 5. Revision der
Invalidenversicherung – No to the
5th Revision of the Disability Insurance
System)
2007 CH Siebdruck – Screen print
127 × 90 cm
Donation Exem

128 Exem (*1951)
Tables de la loi selon Blocher, votez
2 × Non (Gesetzestafeln nach Blocher,
wählt 2 × Nein – Blocher’s Version
of the Stone Tablets, Vote 2 × No)
2006 CH Siebdruck – Screen print
128 × 90,5 cm

129 Exem (*1951)
Le service public à la casse? Non
à la loi sur le personnel fédéral
(Zerstörung des Service Public? Nein
zum Bundespersonalgesetz – End
of the Line for Public Services? No to
the Federal Employees Act)
2000 CH Siebdruck – Screen print
128 × 90,5 cm
Donation Allgemeine Plakatgesellschaft,
APG, Zürich

130 Studio Martin Stoecklin /
Martin Stoecklin (*1983)
Der Rechtsstaat ist in Gefahr /
Alex Capus (The Rule of Law Is under
Threat / Alex Capus)
2016 CH Offset 59,5 × 42,5 cm
Donation Martin Stoecklin

131 Studio Martin Stoecklin /
Martin Stoecklin (*1983)
Shoplifters of the World Unite gegen
die Entrechtungsinitiative! Dorothee
Elmiger (Shoplifters of the World Unite
Against the Initiative to Deprive You
of Your Rights! Dorothee Elmiger)
2016 CH Offset 59,5 × 42,5 cm
Donation Martin Stoecklin

132 Studio Martin Stoecklin /
Martin Stoecklin (*1983)
Einem Viertel der Bevölkerung die
Grundrechte zu verweigern, ist beschä-
mend, unmenschlich, unschweizerisch
und der demokratischen Tradition
unserer gemeinsamen Heimat nicht
würdig. Pedro Lenz (To Deny Basic
Rights to a Quarter of the Population
Is Shameful, Inhuman, Un-Swiss,
and Unworthy of the Democratic
Tradition of Our Common Homeland.
Pedro Lenz)
2016 CH Offset 59,5 × 42 cm
Donation Martin Stoecklin

133 Studio Martin Stoecklin /
Martin Stoecklin (*1983)
Gleich Gesetz dem vor sind Menschen
alle / Melinda Nadj Abonji (Law the
under Equal Are People All / Melinda
Nadj Abonji)
2016 CH Offset 59,5 × 42 cm
Donation Martin Stoecklin

134 Studio Martin Stoecklin /
Martin Stoecklin (*1983)
Die Durchzwängungsinitiative bricht
mit einer der Schweizer Traditionen,
auf die ich immer besonders stolz war:
der Humanität. Martin Suter (The
Enforcement Initiative Breaks with a
Swiss Tradition of Which I Have Always
Been Particularly Proud: Humanity.
Martin Suter)
2016 CH Offset 59,5 × 42 cm
Donation Martin Stoecklin

135 Typosalon / Christof Nüssli (*1986)
Nein zur Zweiklassengesellschaft /
Nein zur Einbürgerungsinitiative
(No to a Two-Tier Society / No to
the Naturalization Initiative)
2008 CH Offset 59,5 × 42,5 cm
Donation Christof Nüssli

136 Noël Fontanet (1898–1982)
1 Milliard pour les retraites du person-
nel fédéral? Non (1 Milliarde für Bun-
desangestelltenrenten? Nein – 1 Billion
for Federal Employee Pensions? No)
1939 CH Lithografie – Lithograph
128 × 90,5 cm

137 Anonym
12 × mehr Lohn ist genug. 1:12 Ja!
(12 × More Pay Is Enough. 1:12 Yes!)
2013 CH Offset 128 × 90,5 cm
Donation Allgemeine Plakatgesellschaft,
APG, Zürich

138 Anna Frei (*1982)
Auch Du bist Stadt / Auch Du kannst
weggewiesen werden / Nein zum
neuen Polizeireglement (You, Too, Are
the City / You, Too, Can Be Removed /
No to the New Policing Regulations)
2005 CH Offset 128 × 90,5 cm
Donation Allgemeine Plakatgesellschaft,
APG, Zürich

139 Peter Birkhäuser (1911–1976)
Zuviel! Vermögensabgabe: Nein
(Too Much! Capital Levy: No)
1936 CH Lithografie – Lithograph
127 × 90 cm

140 Donald Brun (1909–1999)
Freiheit / Ordnung / Fortschritt /
Wirtschaftsartikel Ja (Freedom / Order
/ Progress / Economic Articles of the
Constitution Yes)
1947 CH Lithografie – Lithograph
127 × 90 cm

141 Viktor Rutz (1913–2008)
Piazza pulita! Legge federale sulla
concorrenza sleale Sì (Sauber machen!
Neues Gesetz zum unlauteren Wett-
bewerb Ja – A Clean Sweep! New Law
on Unethical Competition Yes)
1944 CH Lithografie – Lithograph
126,5 × 90 cm

142 Typosalon / Christof Nüssli (*1986)
Wer schützt uns vor der Polizei? Nein
zum Polizeigesetz (Who Will Protect Us
from the Police? No to the Police Act)
2008 CH Siebdruck – Screen print
50 × 34 cm
Donation Christof Nüssli

143 David Rust (1969–2014)
Non au mécanisme de frein à
l'endettement / Derrière les sacrifices,
les sacrifié(e)s / Nous décidons l'avenir
de l'état social (Nein zum Mechanis-
mus der Schuldenbremse / Hinter die
Opfer, die Geopferten / Wir entschei-
den über die Zukunft des Sozialstaates
– No to Putting the Brakes on Debt /
Stand Behind the Sacrifices, Those
Sacrificed / We Decide the Future of
the Welfare State)

1998 CH Siebdruck – Screen print
128 × 89,5 cm
Donation David Rust

144 Typosalon / Matthias Gubler
(*1981)
Wer schützt unsere Privatsphäre? Nein
zum Polizeigesetz (Who Will Safeguard
Our Privacy? No to the Police Act)
2008 CH Siebdruck – Screen print
50 × 34 cm
Donation Christof Nüssli

145 David Rust (1969–2014)
Non au mécanisme de frein à
l'endettement / Derrière les sacrifices,
les sacrifié(e)s / Nous décidons l'avenir
de l'état social (Nein zum Mechanis-
mus der Schuldenbremse / Hinter die
Opfer, die Geopferten / Wir entschei-
den über die Zukunft des Sozialstaates
– No to Putting the Brakes on Debt /
Stand Behind the Sacrifices, Those
Sacrificed / We Decide the Future of
the Welfare State)
1998 CH Siebdruck – Screen print
128 × 90,5 cm

146 Werner Müller (1924–1995)
Unsinn (Nonsense)
1973 CH Offset 127 × 90 cm

147 Anonym
Für eine Schweiz ohne Armee und für
eine umfassende Friedenspolitik Ja
(For a Switzerland without an Army and
for a Comprehensive Policy of Peace
Yes)
1989 CH Offset 128 × 90,5 cm

Ausgewählte Literatur / Selected Bibliography

Arnold, Judith, *Eidgenössische Abstimmungsplakate, Quantitative Inhaltsanalyse (1891–1990) und rhetorische Fallstudien,* Master thesis Universität Zürich, Zürich 2005.

Artinger, Kai, «Das politische Plakat – Einige Bemerkungen zur Funktion und Geschichte», in: id. (ed.), *Die Grundrechte im Spiegel des Plakats von 1919 bis 1999,* Berlin 2000, pp. 15–22.

Demarmels, Sascha, *Ja. Nein. Schweiz. Schweizer Abstimmungsplakate im 20. Jahrhundert,* Konstanz 2009.

Demarmels, Sascha, «Plakat Identitäten», in: IG Rote Fabrik Zürich (ed.), *Fabrikzeitung,* October 2011, n.p.

Garufo, Francesco, Christelle Maire, *L'étranger à l'affiche. Altérité et identité dans l'affiche politique suisse 1918– 2010 / Fremdes auf dem Plakat. Anderssein und Identität auf politischen Plakaten in der Schweiz 1918–2010 / Lo straniero in cartellone. Identità e alterità nei manifesti politici svizzeri 1918–2010,* Neuchâtel 2013.

Giroud, Jean-Charles, *Les images d'un rêve. Deux siècles d'affiches patriotiques suisses,* Genf 2005.

Giroud, Jean-Charles, *Les affiches politiques genevoises de l'entre-deux-guerres,* Genf 2009.

Gruner, Erich, *Die Parteien in der Schweiz,* Bern 1969.

Haberstich, Peter, «Skandale und klare Fronten», in: IG Rote Fabrik Zürich (ed.), *Fabrikzeitung,* October 2011, n.p.

Herbez, Ariel, *Affiches BD. Vingt-cinq ans de création genevoise,* Genf 1996.

Herbez, Ariel, *Exem à tout vent,* Paris 2005.

Kergomard, Zoé, *Wahlen ohne Kampf? Schweizer Parteien auf Stimmenfang, 1947–1983,* Basel 2020.

Länzlinger, Stefan, «Ein Vierteljahrhundert politische Kommunikation von rechts», in: Schweizerisches Sozialarchiv online, June 14, 2016: www.sozialarchiv.ch/2016/07/14/ein-vierteljahrhundert-politische-kommunikation-von-rechts

Lehmann, Daniela, *Das politische Plakat und die Finanzierung politischer (Plakat-)Kampagnen in der Schweiz,* diploma thesis Zürcher Hochschule der Künste, Zürich 2011.

Lüthy, Edwin, *Das künstlerische politische Plakat in der Schweiz,* Basel 1920.

Margadant, Bruno, *«Für das Volk – Gegen das Kapital». Plakate der schweizerischen Arbeiterbewegung von 1919 bis 1973,* Zürich 1973.

Meylan, Jean, Philippe Maillard, Michèle Schenk, *Bürger zu den Urnen. 75 Jahre eidgenössische Abstimmungen im Spiegel des Plakats,* Lausanne 1979.

Richter, Bettina, «Vor den SVP-Plakaten kann man sich nicht schützen», Interview with Andres Wysling, in: *Neue Zürcher Zeitung* online, September 28, 2011: www.nzz.ch/svp_plakate_propaganda_bettina_richter_schwarz_schaf_minarett_stiefel_alexander_segert-1.12627023?reduced=true

Rotzler, Willy, Karl Wobmann, *Political and Social Posters of Switzerland / Politische und soziale Plakate der Schweiz / Affiches politiques et sociales de la Suisse,* Zürich 1985.

Schiller, Bernd, «Was Farben mit der Politik zu tun haben», in: IG Rote Fabrik Zürich (ed.), *Fabrikzeitung,* October 2011, n.p.

Schmid, Denise (ed.), *Jeder Frau ihre Stimme, 50 Jahre Schweizer Frauengeschichte 1971–2021,* Zürich 2020.

Thalmann, Rolf (ed.), *So nicht! Umstrittene Plakate in der Schweiz 1883–2009,* Baden 2010.

Tribelhorn, Marc, «Brandstifters Ende», in: *Neue Zürcher Zeitung,* September 11, 2015, pp. 50–51.

Vaudan, Lucienne, «Diese Sujets haben für Furore gesorgt», in: *persoenlich.com,* February 17, 2016: www.persoenlich.com/kategorie-werbung/diese-sujets-haben-fur-furore-gesorgt

Voegeli, Yvonne, «Frauenstimmrecht», in: *Historisches Lexikon der Schweiz* online, September 17, 2019: www.hls-dhs-dss.ch/de/articles/010380/2019-09-17

Autoren / Authors

Bettina Richter

Geboren 1964, Kunsthistorikerin. 1996 Dissertation über die Antikriegsgrafiken von Théophile-Alexandre Steinlen. 1997–2006 wissenschaftliche Mitarbeiterin in der Plakatsammlung des Museum für Gestaltung Zürich. Seit 2006 Kuratorin der Plakatsammlung. Nebenbei Tätigkeit als Dozentin an der Zürcher Hochschule der Künste sowie als freischaffende Autorin.

Born in 1964, art historian. 1996 dissertation on the antiwar graphics of Théophile-Alexandre Steinlen. From 1997 to 2006, served as a research associate for the Poster Collection of the Museum für Gestaltung Zürich, since 2006 as its curator. Lectures at the Zürcher Hochschule der Künste and works as a freelance writer.

Jakob Tanner

Professor em. für Geschichte der Neuzeit an der Universität Zürich. Autor mehrerer Bücher zur Geschichte der Schweiz im europäischen Kontext sowie Publikationen zur Drogen-, Medizin-, Körper- und Ernährungsgeschichte. Gründungsmitglied des Zentrums Geschichte des Wissens (ETH Zürich und Universität Zürich) und Mitherausgeber der Zeitschrift *Historische Anthropologie.* Zuletzt veröffentlicht: «Das Kaleidoskop der 1920er-Jahre», in: Cathérine Hug (Hg.), *Schall und Rauch. Die wilden 20er,* Ausst.-Kat. Kunsthaus Zürich, Zürich 2020, S. 192–209.

Professor emeritus of modern history at the University of Zurich. Author of several books on the history of Switzerland in the European context as well as publications on the history of drugs, medicine, the body, and nutrition. Founding member of the History of Knowledge Center (ETH Zurich and University of Zurich) and co-editor of the journal *Historische Anthropologie.* Most recent publication: "Das Kaleidoskop der 1920er-Jahre," in: Cathérine Hug (ed.), *Schall und Rauch: Die wilden 20er,* exh. cat. Kunsthaus Zürich, Zurich 2020, pp. 192–209.

Dank / Acknowledgments

Publikations- und Ausstellungsprojekte sind immer ein willkommener Anlass, den eigenen, umfangreichen Bestand an Plakaten themenspezifisch zu sichten, aufzuarbeiten und zu ergänzen. Für die vorliegende Publikation konnten wir auf viele Plakatklassiker zurückgreifen, die der Sammlung im Verlauf ihrer Geschichte als Donation übergeben wurden. Für das uns geschenkte Vertrauen ebenso wie für Anregungen und Informationen zum Thema möchten wir uns an dieser Stelle ganz herzlich bedanken.

Publication and exhibition projects are always welcome occasions to examine and work with our own extensive holdings of posters with a specific theme in mind, and also to update it with targeted acquisitions. For this publication we were able to draw on numerous classic posters that have been donated to the collection over the course of its history. We would like to use this opportunity to express our sincere thanks for the trust placed in us and for the suggestions and information on the topic.

Museum
für Gestaltung
Zürich

**Eine Publikation des Museum für Gestaltung Zürich
Christian Brändle, Direktor**

**A Publication of the Museum für Gestaltung Zürich
Christian Brändle, Director**

**Ja! Nein! Yes! No!
Swiss Posters for Democracy**
Konzept und Redaktion / Concept and editing: Bettina Richter, Petra Schmid, Nico Lazúla Baur
Gestaltung / Design: Integral Lars Müller
Übersetzung / Translation: Mike Pilewski (Ger.–Eng.)
Lektorat Deutsch / German copyediting: Markus Zehentbauer
Lektorat Englisch / English copyediting: Adam Blauhut
Fotografie / Photography: Ivan Suta
Lithografie / Repro: prints professional, Berlin, Germany
Druck, Einband / Printing, binding: Belvédère, Oosterbeek, the Netherlands

Reihe / Series «Poster Collection»
Herausgegeben von / Edited by
Museum für Gestaltung Zürich, Plakatsammlung
Bettina Richter, Kuratorin der Plakatsammlung / Curator of the Poster Collection
In Zusammenarbeit mit / In cooperation with
Petra Schmid, Publikationen / Publications
Museum für Gestaltung Zürich

© 2021
Zürcher Hochschule der Künste
und Lars Müller Publishers

 The museum of
Zurich University of the Arts
zhdk.ch

Museum für Gestaltung Zürich
Ausstellungsstrasse 60
Postfach
8031 Zürich, Switzerland
www.museum-gestaltung.ch

Museum für Gestaltung Zürich
Plakatsammlung / Poster Collection
sammlungen@museum-gestaltung.ch

Lars Müller Publishers
8005 Zürich, Switzerland
www.lars-mueller-publishers.com

ISBN 978-3-03778-661-1
Erste Auflage / First edition

Printed in the Netherlands

**Wir danken für Unterstützung /
For their support we thank:**

POSTER COLLECTION

01 REVUE 1926

02 DONALD BRUN

03 POSTERS FOR EXHIBITIONS 1980–2000

04 HORS-SOL

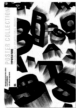

05 TYPOTECTURE

06 VISUAL STRATEGIES AGAINST AIDS

07 ARMIN HOFMANN

08 BLACK AND WHITE

09 RALPH SCHRAIVOGEL

10 MICHAEL ENGELMANN

11 HANDMADE

12 CATHERINE ZASK

13 TYPO CHINA

14 ZÜRICH–MILANO

15 BREAKING THE RULES

16 COMIX!

17 PHOTO GRAPHICS

18 OTTO BAUMBERGER

19 HEAD TO HEAD

20 HELP!

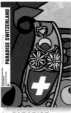

21 PARADISE SWITZERLAND

22 LETTERS ONLY

23 IN SERIES

24 THE MAGIC OF THINGS

25 JOSEF MÜLLER-BROCKMANN

26 JAPAN–NIPPON

27 THE HAND

28 HERBERT LEUPIN

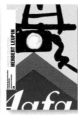

29 HAMBURGER–STAEHELIN

30 SELF-PROMOTION

31 STOP MOTION

32 EN VOGUE